William Morris's Flowers

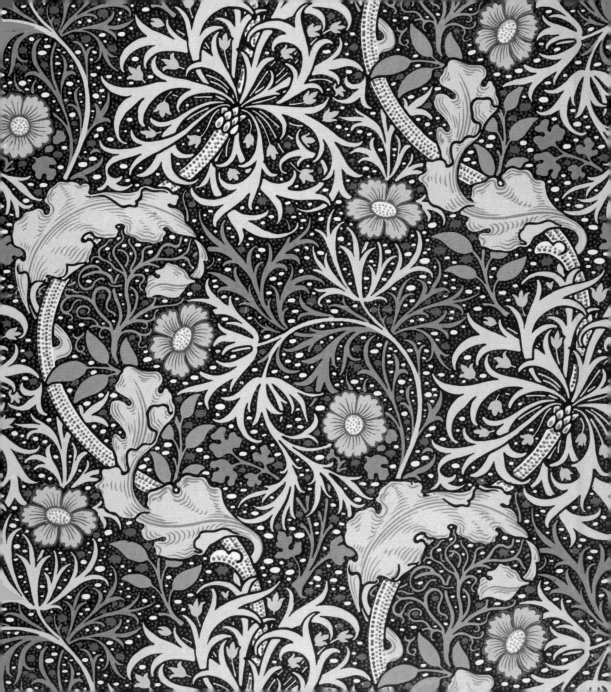

William Morris's Flowers

Rowan Bain

Thames &Hudson | V&A

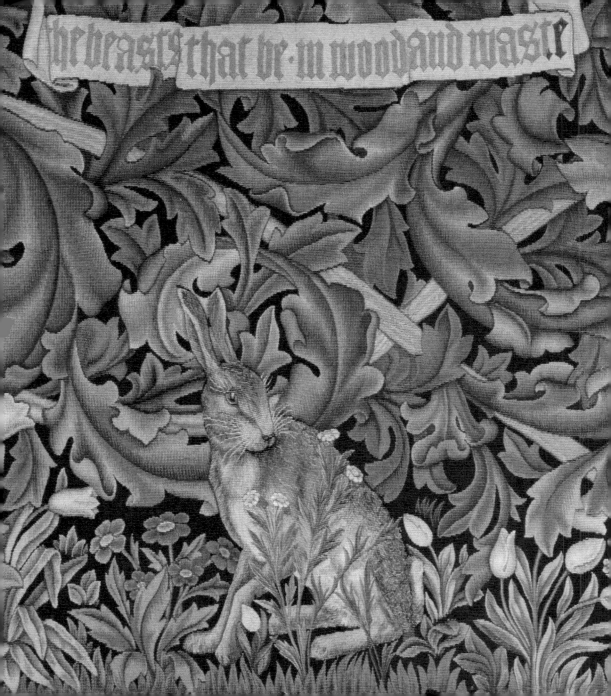

Contents

Preface

Few individuals in Britain have had such a lasting impact on the history of British design as William Morris. A prolific designer of home furnishings, he was also a craftsman, writer, poet, social activist and conservationist. He had achieved so much that when he died aged 62, his doctor declared that the cause was 'simply being William Morris, and having done more work than most ten men'.[1]

Morris's passion for quality craftsmanship, truth to materials, and social idealism helped give rise to the Arts and Crafts Movement, the most significant art movement in Britain from 1880 to the end of the First World War. His influence has also been felt internationally, inspiring design movements in America, Scandinavia and Japan.

During his lifetime, Morris maintained a close relationship with the South Kensington Museum (now the Victoria and Albert Museum). He aligned with the museum's central mission to improve the quality of Victorian art and industry, and spent time studying its collections while also acting in an official capacity as Art Referee. In this role he influenced the acquisition of some of its most important objects, most notably textiles and carpets from the Middle East. In the twentieth century, his daughter May Morris regarded the Victoria and Albert Museum as the natural repository for her father's artistic legacy. She donated a large number of his designs as well as her own, many of which feature in this book.

Arguably, Morris's genius as a designer lay in his ability to distil the wild, rambling British countryside into beautiful,

well-ordered patterns for the home. So successful was he that many of his patterns have never been out of production. Today, some of his best-known floral patterns are still used to decorate walls, furniture, soft furnishings, and much more besides.

Morris's sensitivity to the natural world combined with his innate talent as a designer enabled him to create patterns with endless combinations of flower forms. His ability to adapt, distort and combine them into harmonious patterns means a field guide to all his flowers remains frustratingly elusive. Yet through a deeper understanding of his early influences, gardens, understanding of colour, favourite flowers and approach to their uses in pattern, the visual language of William Morris's flowers can be revealed.

Introduction

'I must have unmistakable suggestions of gardens and fields'

William Morris (1834–1896) was one of the nineteenth century's most important designers (fig. 2). One of the principal founders of the Arts and Crafts Movement, he championed handmade craftsmanship, truth to materials and the use of nature as a source of pattern design. Through his firm Morris & Co. he was responsible for producing hundreds of patterns for wallpapers, furnishing fabrics, tapestries, carpets and embroideries, helping to introduce a new aesthetic into British interiors.

Morris created a visual language that is uniquely 'Morrissian' – recognizable through his skilful arrangement of flowers, winding stems and undulating leaf shapes. His ability to capture both the beauty of British gardens and the wildness of its countryside into complex, well-ordered and attractive patterns for the home appealed to Victorian customers, and continues to resonate with audiences today.

For Morris, the negative effects of the Industrial Revolution – pollution, construction on a massive scale, and oppressive and alienated working conditions – combined to form an anxiety that Britain's 'green and pleasant land' was in danger of disappearing. Throughout his life he was to fight against this menace in remarkable ways: from challenging industrial manufacturing and its dehumanizing effect on workers by promoting quality handmade production, to agitating for full-scale revolution. His conviction that art and craft could change people's lives for the better means that Morris's floral patterns should not be regarded merely as reminders of a lost, bucolic past. Instead his patterns bring nature

Fig. 2 Photograph of William Morris in his work smock, by an unknown photographer, c.1876
William Morris Gallery, London
(WMG: PP1/Z521)

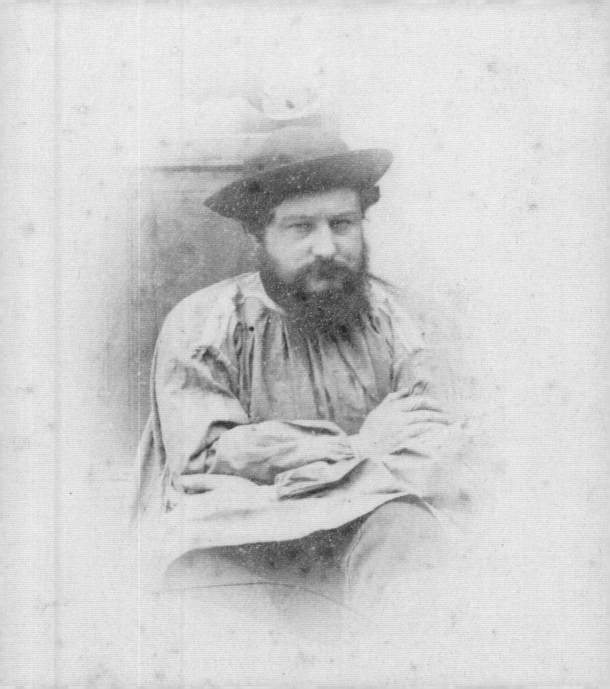

over the threshold, covering walls and furniture with flowers, trees and plants, reminding the Victorian public what there was to lose if the march of industrial 'progress' remained unchallenged.

Childhood influences

There was no indication in Morris's upbringing of his future career as a designer, yet his childhood experiences laid the foundation for a lifelong appreciation and spiritual connection to the world of art and the natural environment.

Morris was the eldest boy of nine children, and as he acknowledged, had 'the good luck only of being born respectable and rich'.[2] This privileged upbringing was afforded by the financial success of his broker father. The Morris family occupied a series of large houses in and around Walthamstow and Woodford – pleasant Essex villages providing the benefits of country living, while still close to London.

Although the rural character of this area was to change within Morris's lifetime, in the mid-nineteenth century it still maintained a sense of being cut off from London. This was mainly due to the broad marshlands of the River Lea, a tributary of the Thames, which formed a natural barrier separating the area from the capital's easternmost reaches. Morris would later name a pattern after the river (fig. 3). In his 1890 novel, *News from Nowhere*, Morris evoked his childhood impressions of the empty Essex landscape, describing: 'the wide green sea of the Essex marshland, with the great domed line of the sky, and the sun shining down in one flood of peaceful light over the long distance'.[3]

The nearby ancient woodland of Epping Forest was also a site of regular exploration for the young Morris. From the large parkland estate of Woodford Hall, his home from 1840 until 1847, he would set out on his pony, traversing the forest which he later claimed to know 'yard by yard'.[4] The tapestries that hung in the Elizabethan hunting lodge on the forest's edge held

Fig. 3 *Lea* furnishing fabric, designed by William Morris and manufactured by Morris & Co. Design registered 2 February 1885 Indigo-discharged and block-printed cotton Victoria and Albert Museum, London (V&A: T.610-1919)

particular fascination for him: 'How well I remember as a boy my first acquaintance with a room hung with faded greenery…and the impression of romance it made on me.'[5] Morris's own tapestry production would attempt to emulate the historical romance he experienced in first encountering the art form as a boy.

From a young age, Morris was an avid reader, and many books he discovered in his father's library as a child were to remain lifelong favourites. One such book was *Gerard's Herball* (fig. 4), a guide to the uses of plants compiled by the sixteenth-century botanist and herbalist John Gerard. As a child Morris spent many hours poring over its woodcut illustrations of plant forms, and in adulthood he shared his enthusiasm with his daughter May, who remembered how 'my father would point out this and that, such as the special elegance of the curves of the dog-tooth violet combined here with the wood-bell and wood sorrel'.[6] The impact of Morris's early study is suggested later in the flat forms of his floral designs, as well as in his interest in the uses of plants as natural dyestuffs for fabric.

While Morris was a student at Oxford University, his fascination with the past intensified, providing him with an escape into a world of medieval history and poetry. He shared these passions with a close group of male companions, who included his best friend, Edward Burne-Jones (1833–1898). Together Morris and Burne-Jones pursued an interest in art and architecture. They found an affinity with John Ruskin's book *The Stones of Venice* (1853), particularly the chapter 'The Nature of Gothic', in which the art historian and philosopher decried the moral bankruptcy of Victorian art and society, urging a return to the values of the medieval age. Ruskin's views immediately resonated with Morris's rebellious nature and instinctive appreciation of the past, and contributed to his lifelong belief in the transformative power of art.

In their final year at Oxford, Morris and Burne-Jones pledged to follow a new life as artists.[7] Although Morris had little formal art training, after graduating he experimented with becoming an

Fig. 4 A page from *The Herbal, or Generall Historie of Plantes*, by John Gerard
Printed by Adam Islip, Joyce Norton, and Richard Whitakers, 1633
Printed with engraved illustrations
Victoria and Albert Museum, London
(V&A: L.814-1975)

architect, then a painter, finally settling on his chosen career when he discovered a talent for interior design. Morris was later to look back at this period and recall how he had then believed the arts to be in a state of 'complete degradation'; and accordingly, 'with the conceited courage of a young man I set out to reforming all that'.[8]

Designs from nature

Morris developed a professional interest in interior design while decorating his first family home, Red House, near Bexleyheath in

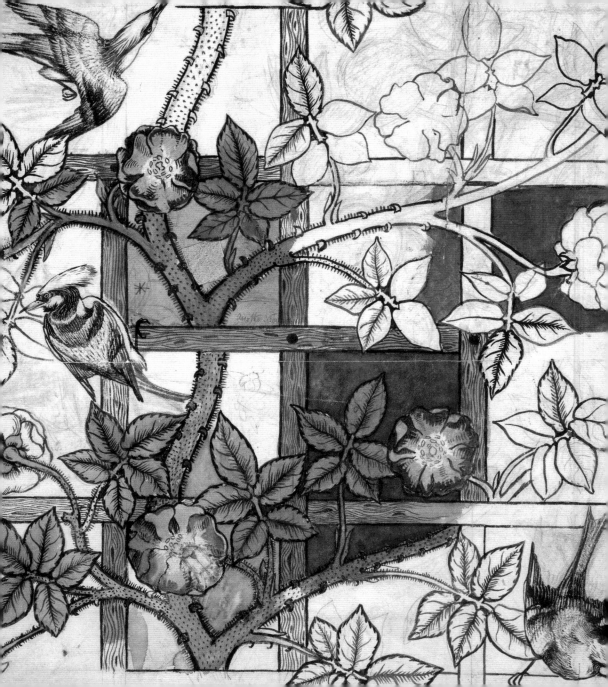

Kent. In 1859 he married Jane Burden (1839–1914), and the couple had two daughters: Jenny (b.1861) and May (b.1862). Completed a year after his marriage, Red House was co-designed with his friend, the architect Philip Webb (1831–1915). The house was constructed of red brick in a style reminiscent of the thirteenth century; it was entirely 'medieval in spirit'. Morris set about furnishing the interior in a sympathetic style. On 11 April 1861, his first design and decorating business, Morris, Marshall, Faulkner & Co., was founded.[9] Renamed Morris & Co. in 1874, it would go on to become one of the most influential design firms of the century.

Spurred on by the embroidered hangings produced for Red House, the firm's first products were chiefly embroideries, but Morris soon turned his attention to designing repeat patterns for use in the home. In 1862 Morris designed his first wallpaper, *Trellis* (fig. 5). This pattern features a neatly squared wooden trellis covered with pretty pink roses, small insects and blue birds (drawn by Philip Webb). The design was in part inspired by the garden of Red House, which was set out in a manner typical of medieval design, comprising a large square subdivided into four by woven wattle fencing.[10] Set within an orchard, the gardens had been pre-planned and pre-planted so that they looked mature when Morris and Jane moved in. Honeysuckle, white jasmine, roses and passion flowers were trained to climb the red brick walls. The pleasant atmosphere of this ordered garden is reflected in the wallpaper.

Despite its enduring popularity today, *Trellis* was not an immediate commercial success. By the 1860s new printing techniques had made wallpaper cheaper to produce and therefore a more accessible alternative to fabric wallcovering. Public taste, however, favoured wallpapers featuring ornate floral motifs made to look as realistic as possible. By comparison, Morris's design appeared quite simplistic.

In later years, Morris articulated his opposition to the Victorian taste for realistic floral motifs:

Fig. 5 Design for *Trellis* wallpaper,
by William Morris and
Philip Webb, 1862
Pencil, pen, ink and
watercolour on paper
William Morris Gallery, London
(WMG: BLA472)

Is it not better to be reminded however simply of the close vine trellises which keep out the sun…or of the many-flowered meadows of Picardy…Is not all this better than having to count day after day a few sham-real boughs and flowers, casting sham-real shadows on your walls, with little hint of any-thing beyond Covent Garden in them?[11]

Morris's ideas would eventually provoke a change in fashion, and the Arts and Crafts aesthetic that he helped create would become the prevailing style for fashionable interiors. Key to this was his approach to pattern design and his interpretation of natural forms, which were, and still are, regarded as transformational and desirable.

Designed in 1862, *Daisy* wallpaper (fig. 6) provided a straightforward naturalism similar to *Trellis*. Unconnected clumps of yellow daisies, red columbine and red and white meadow flowers scatter the surface, the background suggestive of blades of grass.[12] While these early wallpapers demonstrate Morris's restraint as a novice pattern designer, their lack of ornamentation and limited colour palette also give them a modern quality that makes them still popular as decoration in homes today. The simplicity and cosy naturalism of the flower shapes would prove endlessly adaptable for Morris, who used them as decoration for tiles (**plate 1**), stained glass (**2**) and book illustrations.

While the garden at Red House was the physical embodiment of Morris's emergent design aesthetic, the garden landscape of his later home, Kelmscott Manor in Oxfordshire, embodied the extent of his emotional and spiritual connection to the outside world. In the early summer of 1871, he had set out to look for a house outside London where Jane and their two daughters could spend the summer months. Ostensibly for the benefit of his family's health, the rural location was also chosen to conceal the love affair of his wife, Jane, with the artist (and Morris's good friend)

Fig. 6 *Daisy* wallpaper, designed by William Morris and manufactured by Jeffrey & Co. for Morris & Co. Designed 1862, registered 1 February 1864 Block-printed in distemper colours on paper Victoria and Albert Museum, London (V&A: E.442-1919)

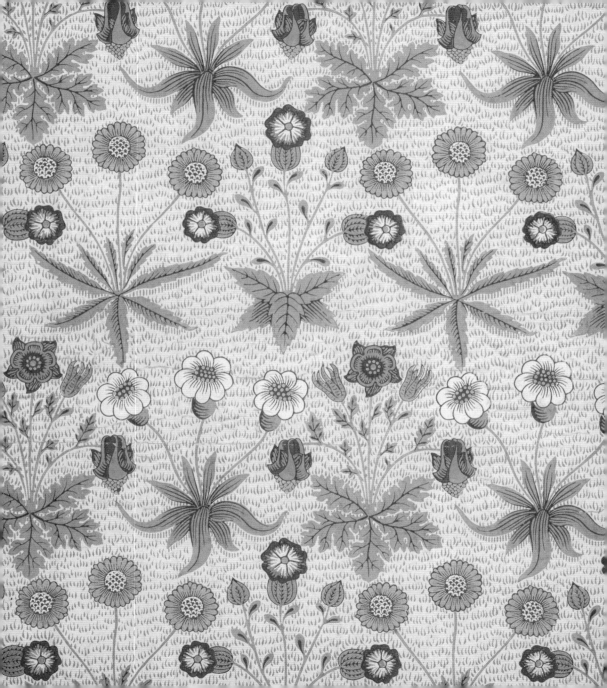

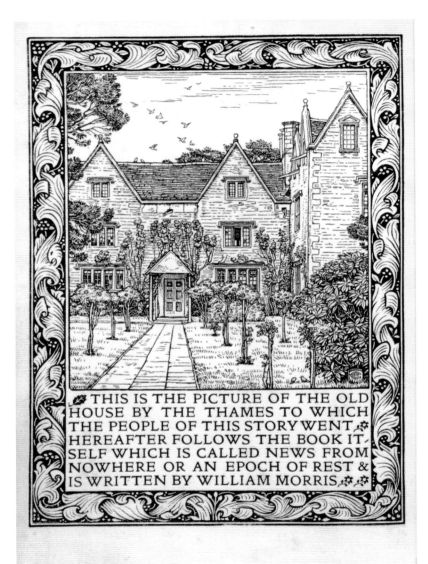

THIS IS THE PICTURE OF THE OLD HOUSE BY THE THAMES TO WHICH THE PEOPLE OF THIS STORY WENT. HEREAFTER FOLLOWS THE BOOK IT-SELF WHICH IS CALLED NEWS FROM NOWHERE OR AN EPOCH OF REST & IS WRITTEN BY WILLIAM MORRIS.

Dante Gabriel Rossetti (1828–1882). In what would be regarded as unusual circumstances even today, Morris, Jane and Rossetti attempted to navigate the situation with a degree of civility. That it was Morris who went in search of the lovers' hideaway is just one of the many intriguing elements to this human drama.

Morris's search led him to Oxfordshire, and the remote village of Lechlade, where he first set eyes on Kelmscott Manor (fig. 7). The beautiful sixteenth-century manor house, built from grey Cotswold stone and surrounded by orchard and gardens, captivated Morris at first sight: 'a heaven on earth', he proclaimed to a friend, 'an old stone house like Water Eaton, and such a garden! Close down on the river, a boat house and all things handy.'[13] Jane's affair with Rossetti would eventually come to an end, yet Kelmscott Manor endured as the country retreat for the Morris family until May's death in 1938.

Although there are no surviving accounts that describe Morris working in the garden himself, at Kelmscott he was able to observe the changing of the seasons at first hand. His first biographer, J.W. Mackail, used extracts from Morris's letters to summarize the seasonal movements in the garden. In winter Morris wrote of crocuses, winter aconites and yellow jasmine; in spring, life was everywhere, the fields all 'butter-cuppy' and the garden itself filled with tulips, white bluebells and Iceland poppies. By summer there were hollyhocks, willow-herb and 'purple blossom of house mint and mouse-ears'; and finally in autumn, 'a pale sweetbriar blossom among the scarlet hips'.[14] Morris's correspondence reveals the sensory delight he derived from his garden, and – ever the poet – his linguistic pleasure in listing the colloquial names of plants and flowers that grew around the property.

In the final year of his life, Morris dwelt on the relationship between Kelmscott and its grounds, writing that the garden looked 'if not a part of the house, yet at least the clothes of it: which I think ought to be the aim of the layer out of a garden'.[15] Prefiguring this, 'Making the Best of It', one of his earliest

Fig. 7 Woodcut of Kelmscott Manor in *News From Nowhere*, designed by Charles March Gere, with border design by William Morris
Printed by the Kelmscott Press, 1893
Paper with half-holland binding
William Morris Gallery, London
(WMG: K5)

lectures on design, delivered in 1880, sets out to describe the ideal garden for a home: 'It should by no means imitate either the wilfulness or the wildness of Nature, but should look like a thing never to be seen except near a house.' With its herbaceous borders and neighbouring meadows, Kelmscott was the ultimate realization of this vision.

'Beauty, imagination and order'

Morris's ideas for how the garden should be contained are intimately linked to his thoughts on pattern design: 'Ornamental pattern work…must contain three qualities: beauty, imagination and order.'[16] Order was the framework on which his design was constructed: 'It builds a wall against vagueness and opens a door therein for imagination to come in.'[17] The flowers in Morris's patterns are not allowed to ramble; instead, as in *Trellis*, they are trained as though in a garden to take the course directed by him. Hardly a flower or leaf shape in his wallpaper or textiles avoids being ordered through a structure, which is achieved through repetition or compositional devices such as scrolling stems. *Honeysuckle* (**fig. 8** and **plate 18**), for example, designed in 1876 as a print for fabric – and not to be confused with May Morris's 1883 wallpaper design of the same name (**23**) – is organized via the ogee shapes formed by the stems of the plant, which act as a framing device to contain the blousy poppy heads and the honeysuckle flowers that cartwheel over the surface.

Importantly Morris took great care to ensure harmony in his pattern repeats in order to 'attain a look of satisfying mystery'.[18] He was alert to the human eye's quest for imperfection, so the repeat is often hard to perceive. Complex patterns such as *Chrysanthemum* (**19**) and *Wreath* (**44**) demonstrate this very well, with large flower heads arranged in rhythmical fashion that avoids boring repetition. The mystery, and his genius, was to make it appear effortless.

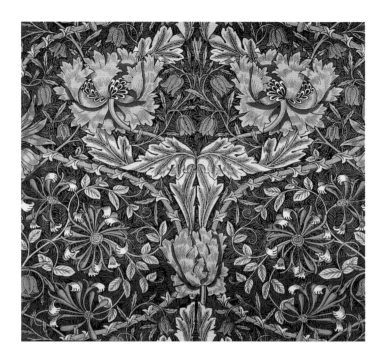

Fig. 8 *Honeysuckle* furnishing
fabric, designed by William
Morris and manufactured by
Wardle & Co. for Morris & Co.
Design registered 11 October 1876
Block-printed cotton
Victoria and Albert Museum, London
(V&A: Circ.196-1934)

The natural world was the place to which he turned most
frequently for sources of inspiration: 'I must have unmistakable
suggestions of gardens and fields and strange trees or I can't do
with your pattern.'[19] However, Morris was acerbic in his criticism
of designers who tried to imitate the beauty of nature directly:

> If you are to put nothing on it but what strives to be
> a literal imitation of nature, all you can do is to have
> a few cut flowers or bits of boughs nailed to it, with
> perhaps a blue-bottle fly or a butterfly here and there.
> Well, I don't deny that this may make good decoration
> now and then, but if all decoration had to take that form

I think weariness of it would drive you to a white-washed wall; and at the best it is a very limited view to take of nature.[20]

Herein lies Morris's appeal: the suggestion of the British countryside while not having to confront the wild, untamed reality; and a symbolic representation of its splendour, as opposed to a direct copy that would only serve as a reminder that the real thing is much more beautiful.

Favourite flowers

Botany was one of the most popular scientific fields in Victorian England: affordable and easily taken up as a hobby by anyone with access to the outdoors, it had wide appeal to the general public. Morris had an extensive knowledge of British flora and fauna built up through observation and study, on which he was able to draw when he sat down to undertake a design. Yet his flowers have little in common with the realistic style of botanical illustrations popularized in books and periodicals from the period. Instead Morris's flowers are a mixture of stylized versions of the real thing, and recognizable flowers that he returned to over and over again.

From as early as 1873, patterns such as *Tulip and Willow* (**fig. 9**) show Morris mastering the use of scale and colour in his floral designs.[21] By the 1880s, he had developed an abundant vocabulary of flower shapes that made for more sophisticated and varied patterns. *Windrush* (**fig. 10**), *Wandle* (**31**) and *Cray* (**33**), all designed between 1883 and 1884, and part of his series named after tributaries of the River Thames, demonstrate his ability to create ever more complicated designs featuring large, heavy flowers such as peonies and poppies, set against smaller, complex and varied combinations of vegetation and blossoms.

Some flowers proved endlessly adaptable. Roses, Morris effused, were 'queen of them all – the flower of flowers'.[22] He grew

Fig. 9 *Tulip and Willow* furnishing fabric, designed by William Morris and manufactured by Morris & Co. Designed 1873, manufactured after 1883
Indigo-discharged and block-printed linen
Victoria and Albert Museum, London (V&A: Circ.91-1933)

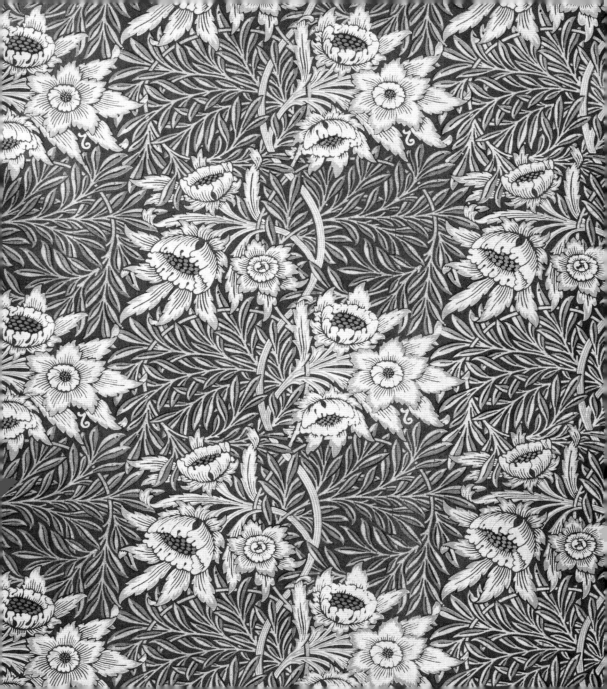

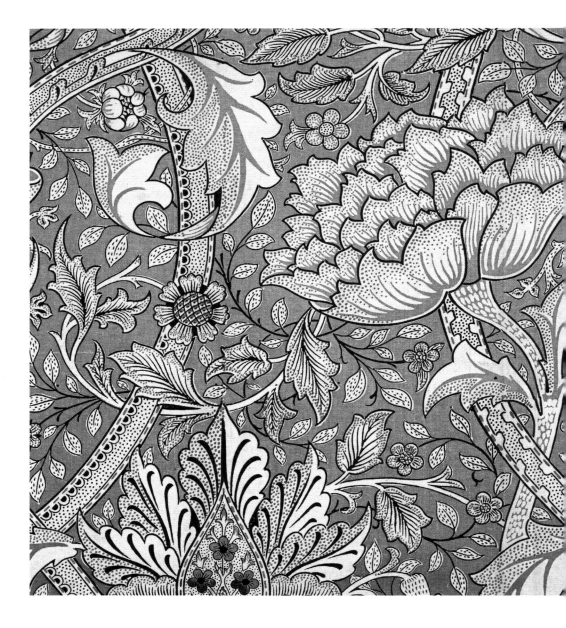

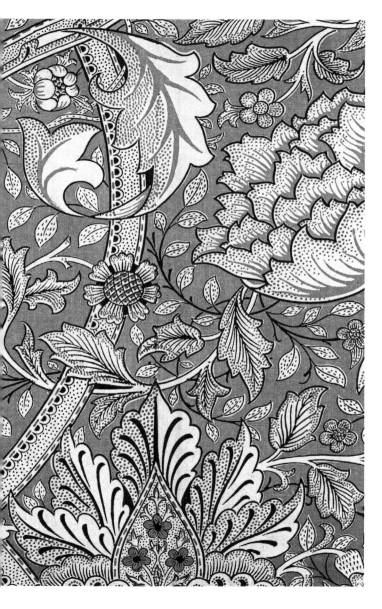

Fig. 10 *Windrush* furnishing fabric,
designed by William Morris and
manufactured by Morris & Co.
Design registered 18 October 1883
Block-printed cotton
Victoria and Albert Museum, London
(V&A: T.617–1919)

old roses in his gardens, but also applied them as motifs in his patterns' designs such as *Trellis* (fig. 5), *Powdered* (5), *Rose* (42 and 43) and *Pink and Rose* (59). The thorny, twisted stems provided a convenient natural structure with which to form his pattern, while the flower head has a recognizable profile from both the front and side, allowing him to create variety and interest when applied to his flat patterns.

Other flowers that frequently appear in Morris's patterns are poppies, peonies, carnations and tulips. These proved infinitely adaptable and in part contributed to the formation of a 'house style'.

As the success of the firm grew in the 1870s and 1880s and Morris's name became more famous, it was necessary to take on more designers. Nonetheless Morris himself maintained a firm grip over production, and even after his death in 1896 his floral vocabulary enabled those working for the firm to produce patterns firmly attributable to Morris & Co. Morris's most successful pupil was John Henry Dearle (1859–1932). Having joined the firm as a young man, his talents as a designer were quickly recognized. He would eventually become Morris & Co.'s artistic director and was responsible for many of their most popular later floral designs.

Merton Abbey

In 1881, Morris centralized his firm's production in one factory at Merton Abbey in Surrey.[23] This rural, seven-acre site provided the space he needed to expand the range of Morris & Co. products manufactured in-house. The site had been a former silk-weaving factory and was situated on the River Wandle, which provided the supply of fresh running water necessary for dyeing and printing textiles.

Morris set out to transform the surroundings of Merton Abbey. He had been profoundly affected by his impressions of northern factory towns, namely the poisoned air, polluted water and undignified working conditions. At Merton he had daffodils planted under the willows by the river, as well as lilies,

larkspur and wallflowers, and in spring the site was covered with primroses and violets.[24] Morris also let out plots of the kitchen garden to some of the workmen. It was as though his flowery patterns needed to be born of their surroundings.

May Morris noted in her introduction to the 23rd volume of *The Collected Works of William Morris* (1910) how one could have scarcely imagined her father 'settled in a neat brick factory with all the latest fittings'.[25] Her descriptions of Merton Abbey provide one of the most detailed and attractive accounts of what Morris achieved there: the dye shop where brightly coloured skeins of fabric were plunged into the hot steaming vats, and the willow tree outside pressing at the window; the weaving shed that contained the jacquard looms on which woven fabrics were produced; and across the water, the largest of the buildings containing huge tapestry and carpet looms. Beside the outbuildings were meadows where printed cloth was laid out to dry and bleached under the sun. 'The whole impression of the place', wrote May, 'was sparkling water with sweet flowered margin, poplars and willows.'[26]

The ramshackle collection of weatherboarded sheds, river, ponds and meadows at Merton seemed to chime with Morris's preference for the old handmade processes, which he argued achieved greater quality than mechanical production. However, Merton Abbey was a place of economic efficiency, and had some way to go before it could fulfil the ideal factory Morris himself would describe in his 1884 essay 'A Factory As It Might Be'.[27] Yet for the Arts and Crafts communities who followed him, its achievements as a centre for creativity and its idyllic surroundings provided a standard to which many aspired.[28]

Dyes and dyeing

Before Morris's move to Merton, he established a relationship with the master dyer Thomas Wardle (1831–1909). From 1875, at Wardle's factory in the small industrial town of Leek,

Staffordshire, they experimented with reviving old dyeing techniques that relied on organic materials to create the spectrum of colours demanded by Morris for his patterns. These included indigo for blue; wild mignonette, a herbaceous plant, for yellow; walnut roots and shells for brown; and cochineal and kermes, both insects, and the root of madder, for red. It was 'as if the cloths were stained through and through with the juices of flowers', wrote Morris's friend, the architect William Lethaby.[29] Morris's insistence that natural dyestuffs be used to colour his wares means there is an undoubted synergy between his botanical designs and the natural materials used to create them.

Morris was critical of newly developed chemical dyes which, while making a huge array of colours available for the first time, he believed were unable to achieve the quality of finished product for which he strived. He became obsessed with achieving the exact colours that would best complement his patterns. Later, at Merton, his printed designs became ever more complex, as the layers of colour and pattern built up through the application of a series of printing blocks, one for each corresponding part of the design, and for each ink colour (26–27). This costly process, each colour requiring individual hand-carved blocks, and the cloth to be washed and fixed between each colour, was secondary to Morris's demanding pursuit of quality.

In his lecture 'Making the Best of It', Morris advised on the best application of colour for interior decoration.[30] For example, he asserted that yellow suited the reflective properties of silk, but was deadened when applied to the dull surface of cotton chintz. These exacting principles were also advocated by May Morris who, like her father, sought to elevate standards of craft and design. May championed the use of naturally dyed embroidery silks, creating embroideries such as *Flowerpot* (66) in which the soft natural shades perfectly complement the delicate floral design. In *Decorative Needlework*, her 1893 guide to embroidery, she advised which colours did and did not work well together, eschewing the

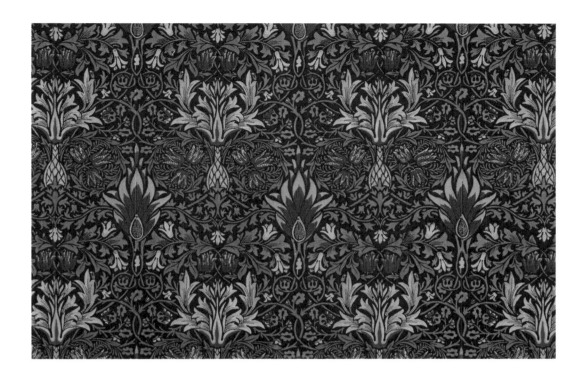

Fig. 11 *Snakeshead* furnishing fabric,
designed by William Morris and
manufactured by Wardle & Co. for
Morris & Co.
Designed 1876, manufactured from 1877
Block-printed cotton
Victoria and Albert Museum, London
(V&A: T.37-1919)

notion that colour should be left up to the fickle impulses of the
novice designer.[31]

Middle Eastern and South Asian influences

Morris admired the fact that contemporary cottons imported
from India were hand-printed with natural rather than chemical
dyes. Between late 1875 and 1877 he produced a small group of
patterns influenced by Indian colours and patterns. *Snakeshead*
(fig. 11) is printed in strongly contrasting reds and blues with
large palmette-shape flowers that have their origins in South Asian
motifs. Other smaller scale prints, for example *Indian Diaper* (55)

Fig. 12 Design for *Acanthus* embroidery,
by William Morris, *c.*1880
Pencil and watercolour on paper
Victoria and Albert Museum, London
(V&A: E.55-1940)

and *Little Chintz* (57), also have much in common with the small repeating flower patterns characteristic of South Asian block-printed cottons.

Morris derived most pleasure from looking back to historic design traditions for inspiration. As May Morris wrote, 'The designs of the ancient world were stored in his mind for reference.'[32] He was a frequent visitor to the South Kensington Museum, and as a connoisseur he collected decorative arts from the Middle East, furnishing his home with carpets, embroideries, velvets, ceramics and decorative metalwork from Iran and Turkey. Morris's veneration of Middle Eastern pattern design was characteristically rooted in a romantic sense of the past: 'In their own

INTRODUCTION

way', he effused, 'they meant to tell us how flowers grew in the gardens of Damascus...or how the tulips shone among the grass in the mid-Persian valley, and how their souls delighted in it all and what joy they had in life.'[33]

There is evidence of his admiration for Middle Eastern design motifs in some of his flower patterns. Pinks (from the same family as the carnation), for example, used in the patterns *Pink and Rose* (59), and tulips in *Medway* (38), are both flower shapes that have their origins in pottery from the Ottoman city of Iznik (northwest Anatolia) as well as textiles from Safavid Iran, which Morris himself collected and displayed in his home. In one of his lectures on pattern designing, Morris said: 'To us pattern-designers, Persia has become a holy land, for there in the process of time our art was perfected, and thence above all places it spread to cover for a while the world, east and west.'[34]

Perhaps the most visible impact came in the 1870s, when he started experimenting with carpet production. At first Morris's designs were fairly crude, consisting of small rugs with a central flower motif, but as he mastered the technique he became more ambitious. He was helped by his study of Turkish carpets, but mainly Safavid carpets from Iran, in particular their set colour palettes and complex planar system of overlaid grids formed of flowers and natural plant forms.[35] Carpets created around the early 1880s, such as *Bullerswood* (63), evidence Morris's increased level of understanding of how two-dimensional pattern could be scaled up to create more complex and large-scale designs.

Embroidery, tapestry and book arts
Influenced by his growing knowledge of historic rugs and textiles from the Middle East, Morris's large-scale designs for hangings such as *Acanthus* (fig. 12 and 67) resemble carpets, with a central motif of complicated interlocking leaves and flowers surrounded by decorative borders.[36] His hands-on approach – teaching

himself carpet weaving, as well as embroidery, weaving and dyeing – equipped him with a highly developed understanding of the limitation and potential of his designs. Armed with this practical know-how, Morris gained valuable insight into how his drawing of a rose or a tulip transferred successfully from the flat page into the stitches of embroidery. This translated more generally across his whole artistic production which, one could argue, demonstrated his deep regard for the particular medium for which he was designing.

Morris & Co.'s embroidery department produced a combination of luxury bespoke and more everyday items for its customers. Among the more affordable products were embroidery kits: chiefly intended to be used at home by the amateur embroiderer, they were also available 'ready-made' by the staff of the embroidery department. A wide range of designs were available, but most, such as *Rose Wreath* (40), feature a central flower, surrounded by scrolling blossoms or foliage. These typically square designs were conceived to fit into fire screens, cushions, or decorative panels.

By the 1870s Morris & Co. was offering ever larger and more sophisticated embroidery designs for its more wealthy clients. In 1885, May Morris became head of Morris & Co.'s embroidery department at the age of 23. She oversaw the selection of colour combinations and materials to suit her father's designs. Her artistic abilities, however, meant that she would soon develop her own style, creating complex and inventive designs for the firm. *Maids of Honour* (68) shows how May excelled in combining subtle use of colour and smaller flowing arrangements of birds, foliage and lettering. Besides her role at Morris & Co. she was also a central figure of the Arts and Crafts Movement, exhibiting her work in many of the major exhibitions associated with it. Her talent and status as a designer–maker helped elevate embroidery from a domestic craft to being considered a serious art form.

One of William Morris's final textile projects was to master the art of weaving. By the 1880s it had long fallen out of fashion,

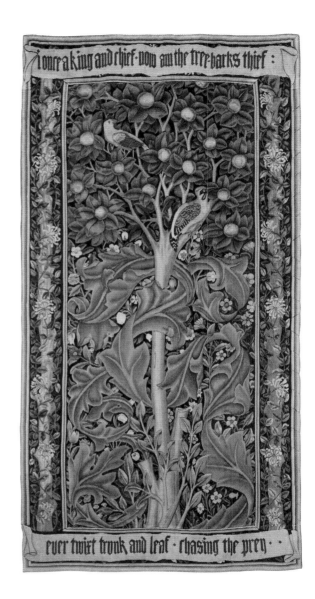

Fig. 13 *Woodpecker* tapestry,
designed by William Morris
with inscription embroidered
by May Morris and assistants, 1885
Wool on cotton lining
William Morris Gallery, London
(WMG: F139)

INTRODUCTION

Fig. 14 Detail from trial pages for
Froissart's Chronicles, designed by
William Morris and printed at the
Kelmscott Press, 1895–6
Ink on paper
Victoria and Albert Museum, London
(V&A: E.504-1903)

but he was determined to revive this 'noblest of the weaving arts'. As with many of Morris's artistic endeavours, his tapestries were a combined artistic effort, the figurative elements frequently designed by his old friend Burne-Jones, the animals drawn by Webb, and either Morris, but more frequently Dearle, applying the floral background. [37] *Woodpecker* (fig. 13), with its woodland scene and brown and blue tones, recalls the faded medieval tapestries Morris had first seen as a child in Epping Forest. However, it is

the rainbow of brightly coloured floral backgrounds featured in the well-loved, and frequently reproduced, hangings such as *Flora* (70) that gives Morris's tapestries their enduring appeal. Resembling a traditional millefleurs (thousand flowers) arrangement, the colourful clumps of flowers at the feet of the beautifully rendered animals, as in *The Forest* (71), are fresh and bright, distinct from the faded tapestries of the past.

Morris's lifelong passion for books and storytelling fed into every aspect of his art. In the 1870s he had created a number of beautiful illuminated manuscripts, including *A Book of Verse* (72), given to Georgiana Burne-Jones. But it was not until the final years of his life that Morris turned his attention to making beautiful printed books. Inspired by the medieval manuscripts he collected, and frustrated with the poor standards of Victorian book design, in 1891 he founded his own private printing company, known as the Kelmscott Press. His aim was to create books with 'a definite claim to beauty', designed to the highest standards and made with the best available materials.

Morris designed all the borders and initials in the books produced by the Kelmscott Press. First he sketched faintly in pencil and then applied Indian ink with a brush, making corrections with Chinese white paint. The decorative borders and letters in works such as *Froissart's Chronicles* (**fig.** 14) not only employ his own distinctive floral patterns but reveal the influence of a lifetime of studying medieval manuscripts.

Morris died at his home in Hammersmith on 3 October 1896. Just a few months earlier he had witnessed the completion of the Kelmscott Chaucer (73), the most ambitious book he ever printed. Taking four years, it was a labour of love and the culmination of Morris and Burne-Jones's long friendship. Morris's book production can be seen as the apogee of a life spent looking backwards to the past, and at the same time reinventing that past and generating a new aesthetic for a modern age.

Plates

The daisy motif on this tile
was initially used by Morris
as a design for his first
wallpaper. The simple flowers
are hand-painted in blue and
yellow glaze applied with
quick, lively brushstrokes.
When multiple tiles are
arranged together, the overall
pattern gives the impression
of a country meadow.

1. *Daisy* tile, designed by William
Morris for Morris, Marshall,
Faulkner & Co., *c.*1862
Hand-painted on tin-glazed
earthenware
Victoria and Albert Museum, London
(V&A: C.58-1931)

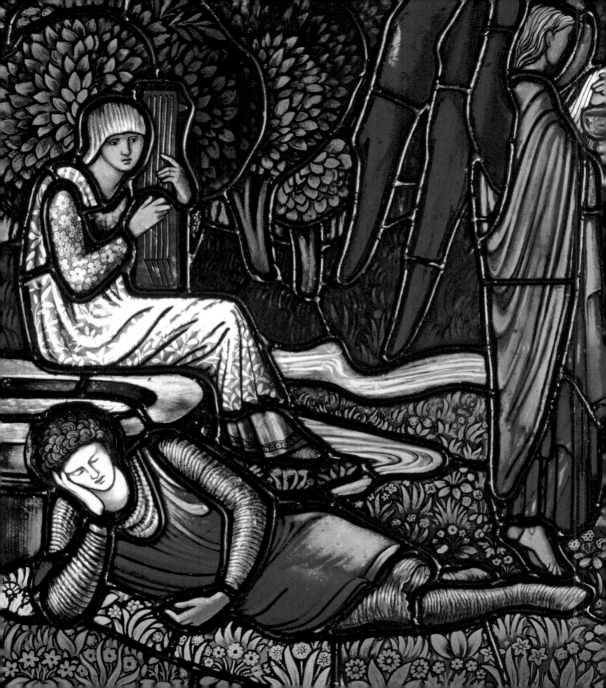

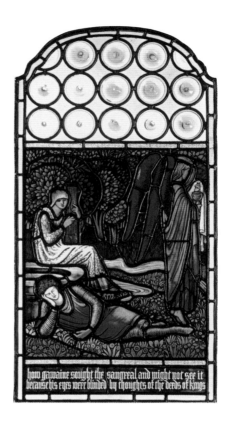

2. 'How Gawaine Sought the Sangreal',
from the stained glass panel series
The Quest for the Sangreal, designed by
Edward Burne-Jones, painted by John
Henry Dearle, and manufactured by
Morris & Co., 1886
Stained glass panel
Victoria and Albert Museum, London
(V&A: C.624-1920)

This stained glass panel, from a four-part series, tells the story of the quest for the Holy Grail. The flowery setting is suggestive of the tale, in which Sir Gawaine takes a rest from his search for the grail, and experiences an allegorical dream set within a meadow filled with herbs and flowers. The familiar daisy motif is used here to great effect: the profile of the small flowers is outlined by the painted black background on green glass.

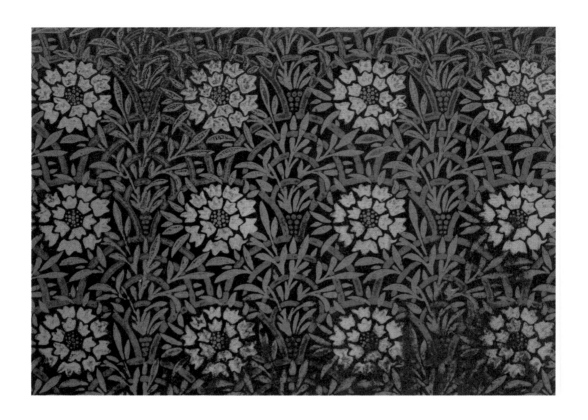

3. *Marigold* linoleum, designed by
William Morris and manufactured
for Morris & Co., possibly by Nairns
of Kirkcaldy, Scotland
Design registered 6 June 1875
Printed cortecine (linoleum)
Victoria and Albert Museum, London
(V&A: Circ.527-1953)

This linoleum was Morris's first design for a floor covering and
the only one intended for this medium. The printed pattern is
of yellow African marigolds arranged against an arched trellis
that is interwoven with willow leaves. Linoleum was invented
in England in 1860, and its hard-wearing properties and
affordability saw it grow in popularity throughout the latter half
of the nineteenth century. This design was produced by Morris
& Co. until around 1915.

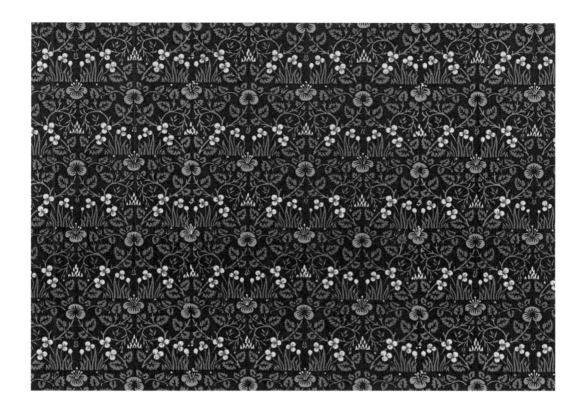

4. *Eyebright* furnishing fabric,
designed by William Morris and
manufactured by Morris & Co.
Design registered 23 November 1883
Indigo-discharged and
block-printed cotton
Victoria and Albert Museum, London
(V&A: T.51-1912)

In this printed cotton, small white eyebright flowers peep out
of the waving clumps of fresh green grass. Another common
meadow flower, the yellow buttercup, contrasts with the dark
blue indigo background. The curving stems form ogee shapes,
creating an overall net pattern linked by the buttercup heads.

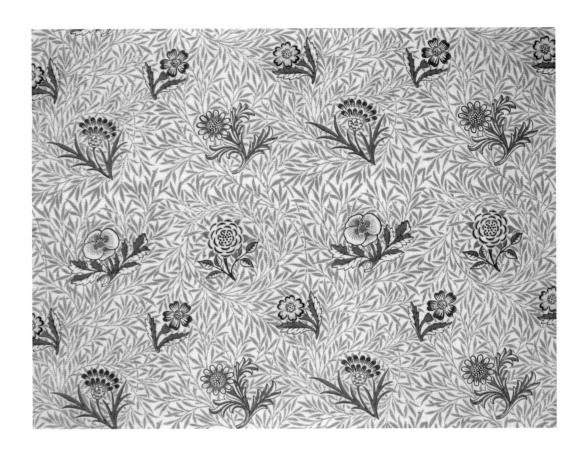

5. *Powdered* furnishing fabric,
designed by William Morris and
manufactured by Morris & Co.
Designed as a wallpaper 1874,
adapted for fabric *c*.1902
Block-printed cotton
William Morris Gallery, London
(WMG: F23)

Powdered takes its name from the relatively informal
arrangement of meadow flower sprigs – unconnected
by a linking device – across the background. The pink
and blue flowers include roses, speedwell, pansies and
cornflowers. This is one of several mid-1870s designs
featuring willow foliage, a favourite motif which
Morris drew with endless inventiveness.

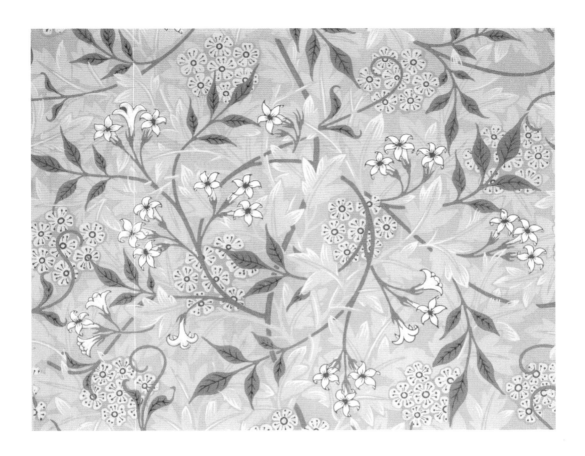

6. *Jasmine* wallpaper, designed by
William Morris and manufactured
by Jeffrey & Co.
Designed 1872
Block-printed in distemper colours
on paper
Victoria and Albert Museum, London
(V&A: E.770-1915)

Several of Morris's early designs feature the jasmine plant,
using the winding stems to create a scrolling tracery within
the overall pattern. In this wallpaper from 1872, the foreground
of white jasmine flowers is combined with hawthorn blossom,
set against the subtle tones of the tree's foliage.

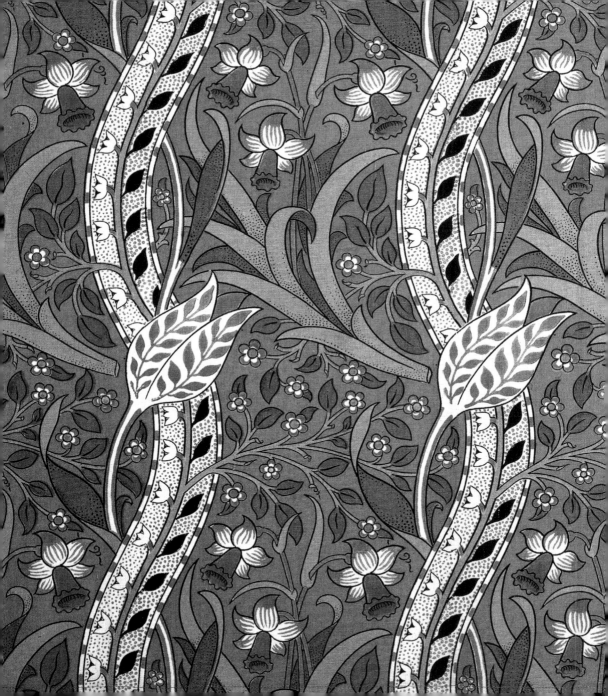

7. *Daffodil* furnishing fabric,
designed by John Henry Dearle
and manufactured by Morris & Co.
Designed *c.*1891
Block-printed cotton
Victoria and Albert Museum, London
(V&A: T.623-1919)

Spring flowers – daffodils, forget-me-nots and stylized tulips
– wrap around strands of decorative ribbon in this design by
John Henry Dearle. Although his earliest designs for Morris
& Co. were closely based on Morris's style, as Dearle matured
he developed his own style, characterized by his competent
drawing ability, clearly defined pattern outlines and the
influence of Middle Eastern textile patterns. After Morris's
death, Dearle became the Artistic Director of Morris & Co.,
creating some of its best-loved patterns.

8. *Blackthorn* wallpaper, designed by
John Henry Dearle and manufactured
by Jeffrey & Co.
Designed 1892
Block-printed in distemper colours
on paper
Victoria and Albert Museum, London
(V&A: E.602-1919)

For this wallpaper, Dearle combines the flowers of the
hedgerow – white blackthorn (or sloe) blossom and violets –
with flowers of the meadow – red snake's head fritillaries and
yellow daisies. Their strong colours stand out brightly against
the dark green background.

White spring blossom and pink clover flower heads sprinkle the surface of this wallpaper, designed by Dearle in 1903. The informal, small-scale pattern suited Edwardian taste, which favoured pastel colours and lighter designs over the darker and heavier patterns of the Victorian era.

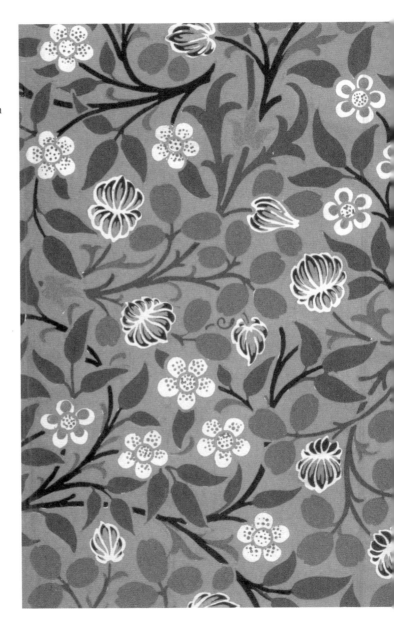

9. *Clover* wallpaper, designed by John Henry Dearle and manufactured by Morris & Co.
Designed 1903
Block-printed in distemper colours on paper
Victoria and Albert Museum, London
(V&A: E.1412-1979)

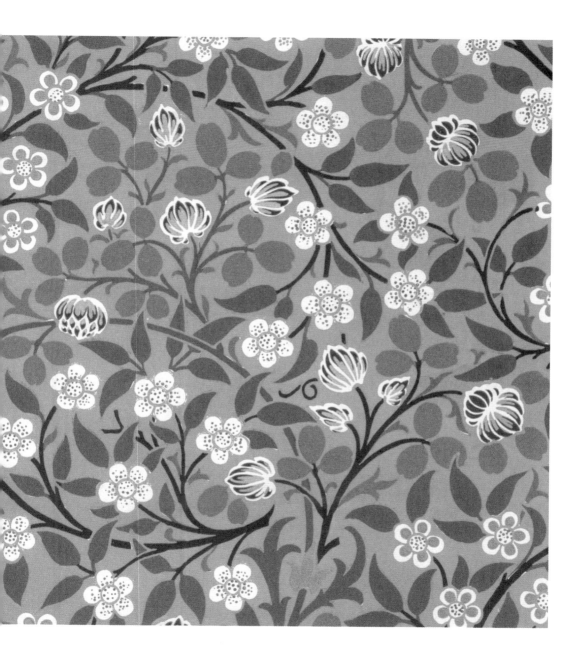

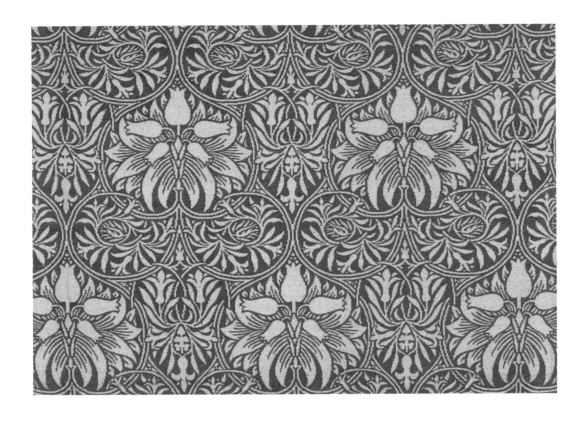

10. *Crown Imperial* furnishing fabric,
designed by William Morris and
manufactured by Dixon, Bradford
for Morris & Co.
Design registered 18 November 1876
Woven wool
Victoria and Albert Museum, London
(V&A: T.22-1919)

The striking flower head of the crown imperial forms the
central motif of this woven wool. Native to south-east Turkey
and western Iran, this species of the lily family has been
cultivated in Great Britain since the sixteenth century and
was one of the earliest bulbs to be grown in British gardens.

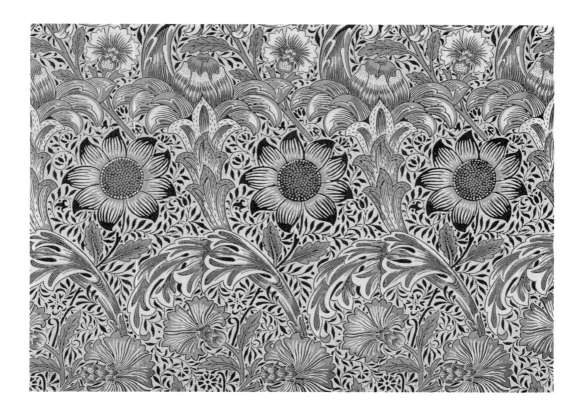

11. *Corncockle* furnishing fabric,
designed by William Morris and
manufactured by Morris & Co.
Design registered 27 February 1883
Block-printed cotton
Victoria and Albert Museum, London
(V&A: Circ.87-1953)

Large sunflower heads and blue and white cornflowers
dominate this design, while the small corncockle flower, from
which the pattern takes its name, forms the more secondary
dark green scrolling mid-ground. Morris usually named
his patterns after the flowers that make up the main design;
sometimes, however, as here, he chose less obvious titles,
revealing perhaps his preference for more poetic plant names.

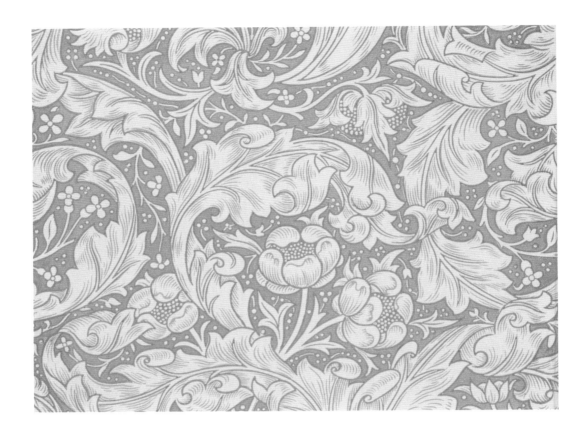

12. *Lechlade* wallpaper,
designed by John Henry Dearle
and manufactured by Jeffrey & Co.
for Morris & Co.
Designed 1893
Block-printed in distemper
colours on paper
Victoria and Albert Museum, London
(V&A: E.2219-1913)

Dearle named this wallpaper after the Oxfordshire village
of Lechlade, where Morris's country home Kelmscott Manor
was situated. The pale tones of blue, yellow, brown and peach
creates a graceful pattern in which Acanthus leaves wrap
around stylized flower heads. The petals are unfurling to
reveal yellow curled stamens and the tightly dotted centres
of the flowers.

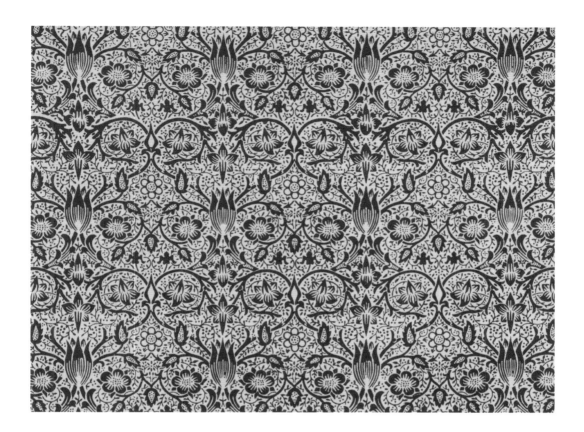

13. *Borage* furnishing fabric,
designed by William Morris and
manufactured by Morris & Co.
Designed 1883
Block-printed cotton
Victoria and Albert Museum, London
(V&A: T.49-1919)

The small scale of this pattern made it suitable for use as a
lining fabric – Morris intended it to be used for lining Morris
& Co.'s heavy woollen curtains. The pattern is named after
the five-pointed star shape of the borage flower. Morris used
a similar configuration of flowers in a ceiling wallpaper of the
same name.

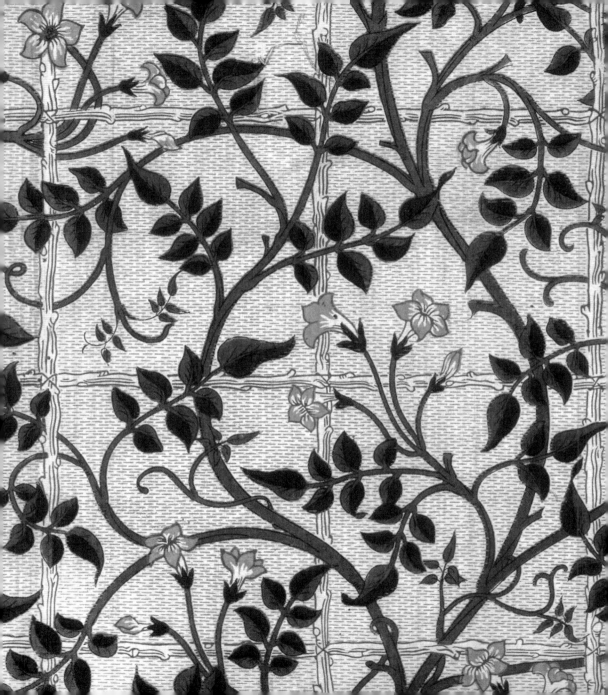

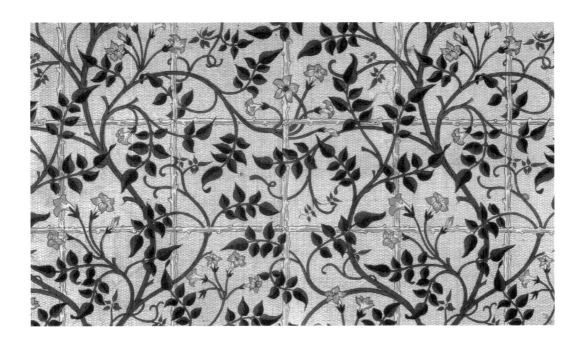

14. *Jasmine Trellis* furnishing fabric, designed by William Morris and manufactured by Clarkson, later Wardle & Co.
Designed 1868–70
Block-printed cotton
Victoria and Albert Museum, London
(V&A: Circ.105-1966)

This is Morris's earliest known original design for a furnishing textile. As with his first wallpaper (fig. 5), he used a square trellis to create a structure to contain the sinuous, winding stems of the jasmine plant. The design conforms closely to the 'Aesthetic' style, with which Morris was associated. The Aesthetic Movement in Britain (1860–1900) aimed to escape the ugliness and materialism of the Industrial Age, with designs that focused on exploring colour, form and composition in the pursuit of beauty. The combinations of fully formed leaves with small emergent tendrils, as well as stems that are cut off mid-growth, are uncharacteristic of Morris's mature designs. He later taught that 'every line should have its due growth'.

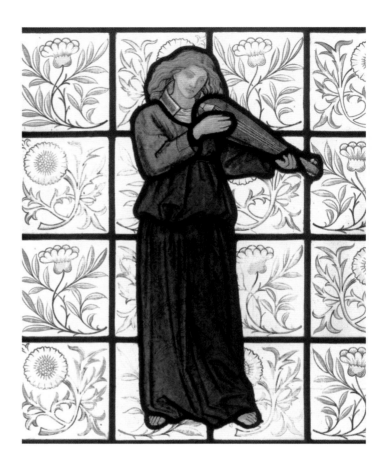

15. *Minstrel* panel, designed by
William Morris and manufactured
by Morris & Co.
Manufactured *c*.1872–4
Stained and painted glass
Victoria and Albert Museum, London
(V&A: C.678-1923)

This lute-playing minstrel in long green robes floats against a
background of stylized flowers, which resemble marigolds and
half-open daisies. As with his designs for tiles, Morris used the
square shape of the leaded window quarries as a structure to
contain his flower motifs.

16. *Tulip and Trellis* tile, designed by
William Morris and manufactured by
William De Morgan
Designed 1870, manufactured 1870–80
Hand-painted on tin-glazed earthenware
Victoria and Albert Museum, London
(V&A: C.220-1976)

This square tile is hand decorated with deep blue tulip heads
on a quartered structure. When arranged together, forming the
surround for a fireplace, for example, the tiles create the effect
of meandering vertical lines of tulips against a garden trellis.

17. *Lodden* furnishing fabric,
designed by William Morris and
manufactured by Morris & Co.
Designed 1884
Indigo-discharged and
block-printed cotton
Victoria and Albert Museum, London
(V&A: T.39-1919)

The numerous flower shapes in this pattern, including tulips,
lotuses, roses and carnations, are combined with acanthus
leaves and curving stems to form a complex design. Single
flower heads are used as connecting devices, linking the
network of scrolling lines. The title of the pattern is a
misspelling of Loddon, a tributary of the River Thames.

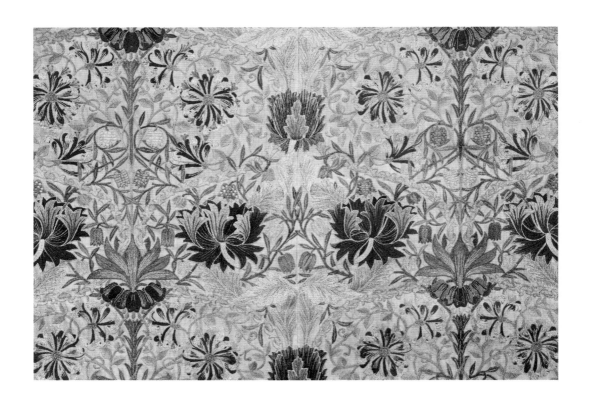

18. *Honeysuckle* embroidery,
designed by William Morris
and embroidered by Jane Morris
and Jenny Morris
Designed 1876, made *c.*1880s
Silk on linen
William Morris Gallery
(WMG: F434)

May Morris, William Morris's younger daughter, described
Honeysuckle as 'the most-truly "Morrisian" in character of all
his pattern-making in mid-life'.[38] Four of his most frequently
used flowers for patterns – crown imperial, tulip, honeysuckle
and fritillary – overlie a dense background of yew. The pattern
was applied to a variety of textile mediums, including cotton,
silk and velveteen as well this magnificent embroidery, which
was worked by Jane, Morris's wife, and their elder daughter,
Jenny Morris. May described it as 'A thing alive with light
and colour'.[39]

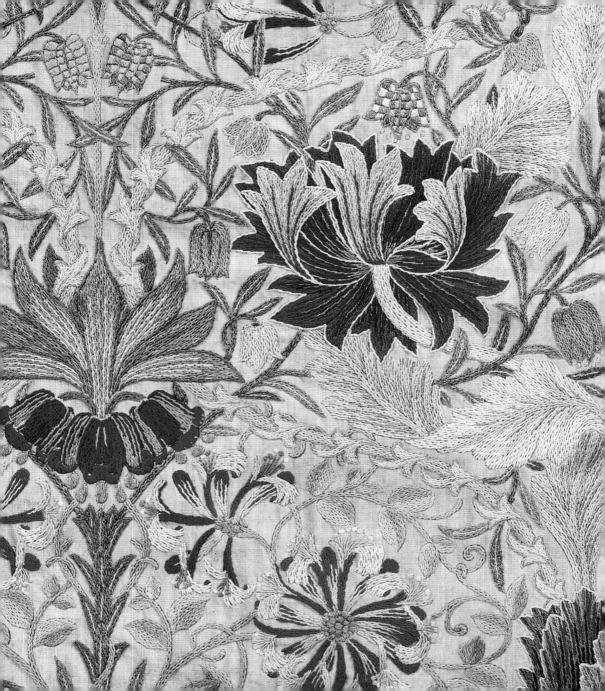

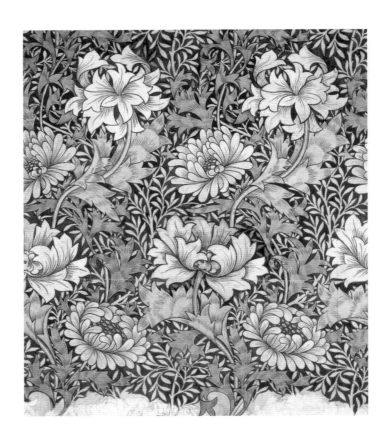

19. Design for *Chrysanthemum*,
by William Morris, 1877
Pencil and watercolour on paper
William Morris Gallery, London
(WMG: A33)

Morris thought all successful patterns should have their basis
in natural forms, but he did not think they should be shown
in three dimensions on a flat wall. This pattern has two layers:
a background of small yellow willow leaves, overlaid with
meandering chrysanthemum flowers and larger blue-green
leaves. The veins on the blue-green leaves and flower petals
hint at their three-dimensional shape, but the yellow leaves
are completely flat.

20. *Marigold* silk, designed by
William Morris and manufactured
by Wardle & Co.
Design registered 15 April 1875
Victoria and Albert Museum, London
(V&A: Circ.496-1965)

The marigold flowers and vertical undulating branches of this
pattern create a striped effect, which made it suitable for use
both as a wallpaper and for cotton and linen furnishing fabrics.
Soon after it was designed, Thomas Wardle experimented with
printing *Marigold* onto silk. However, the narrow width of the
cloth was more suited to dress fabric than furnishing, and
the silk fabric was therefore not taken up by Morris & Co.

Thanks to its monochromatic colour scheme, this dense design of double-petalled anemones and their foliage, stylized sunflower-like flowers and beady-eyed birds maintains a two-dimensional quality. Like *Marigold* (20), it is one of only a few designs intended by Morris to be used as both a furnishing fabric and a wallpaper.

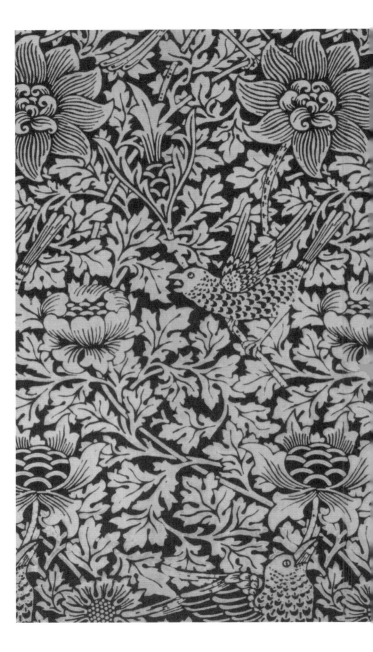

21. *Bird and Anemone* furnishing fabric, designed by William Morris and manufactured by Morris & Co.
Design registered 17 June 1882
Indigo-discharge on cotton
Victoria and Albert Museum, London
(V&A: T.651-1919)

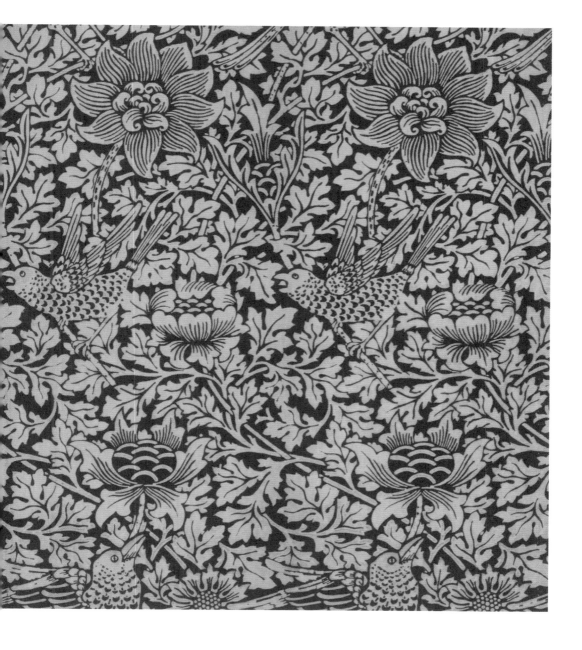

This busy pattern is formed of pairs of plump doves, surrounded by roses, irises, acorns and other floral shapes. Morris designed it specifically as a woven fabric for curtains and hangings, and worked out the repeat in freehand, which was then translated onto graphed pointpaper. Each coloured square corresponded to the passing of the horizontal weft thread over the vertical warp. When translated on the loom, this carefully planned design ensured that the overlapping stems and branches remained clear and distinct.

23. *Honeysuckle* wallpaper, designed
by May Morris and manufactured by
Jeffrey & Co. for Morris & Co.
Designed and manufactured *c.*1883
Block-printed in distemper colours
on paper
William Morris Gallery, London
(WMG: B52)

In the early years of working for Morris & Co., May Morris
designed three wallpapers. Of these, *Honeysuckle* is her most
popular and enduring, demonstrating her early talent as a
pattern designer. Based on a net structure of untamed green
stems, curling leaves and pink honeysuckle flowers on a plain
background, the overall effect is both light and uplifting.

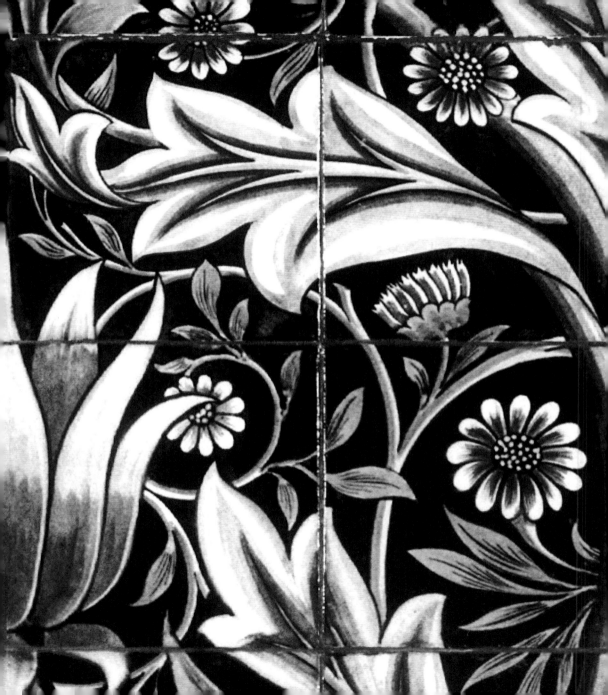

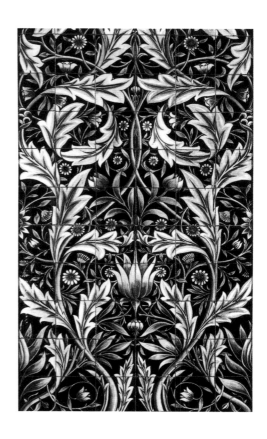

24. Membland Hall tile panel,
designed by William Morris,
manufactured by William De Morgan,
and made by the Architectural Pottery,
Poole, 1876
Slip-covered and hand-painted
in various colours and glazed on
earthenware blanks
Victoria and Albert Museum, London
(V&A: C.36-1972)

The design for this large tile panel, commissioned for
Membland Hall in Devon, is similar to Morris's wallpaper
designs of the same period, with its motifs of scrolling acanthus
leaves and daisies. However, the tiles are composed differently,
with even larger motifs and more free space. In comparison,
Morris's wallpapers, which like these tiles were also designed
to suit a flat surface, had denser, smaller scale patterning more
suited to domestic-sized walls.

25. Design for *Tulip* printed cotton,
by William Morris, 1875
Pencil and watercolour on paper
William Morris Gallery, London
(WMG: BLA500)

Morris advised would-be designers to create forms of flowers
and leaves 'that are obviously fit for printing with a block;
to mask the construction of our pattern enough to prevent
people from counting the repeats'.[40] He worked out his designs
for repeating floral patterns on the page. This design for *Tulip*
corresponds with the size of woodblock (26). The design was
translated by the woodblock cutter so that when the individual
block was applied to the surface of the cloth (27) – each block
providing a different colour or element of detail – the details
of the pattern built up to form a satisfying repeat. *Tulip*
required 12 separate woodblocks.

26. *Tulip* printing block, made by
Barretts of Bethnal Green,
late nineteenth century
Pearwood with metal inlay
William Morris Gallery, London
(WMG: R530)

In the finished printed fabric, the variegated petals of the tulip flowers are shown to full effect, using stripes of blue set out in a fan shape. The horizontal bands of tulips – their heads facing in opposite directions – are connected by vertical lines of leafy foliage set against a contrasting background of orange scrolling flowers and leaf shapes.

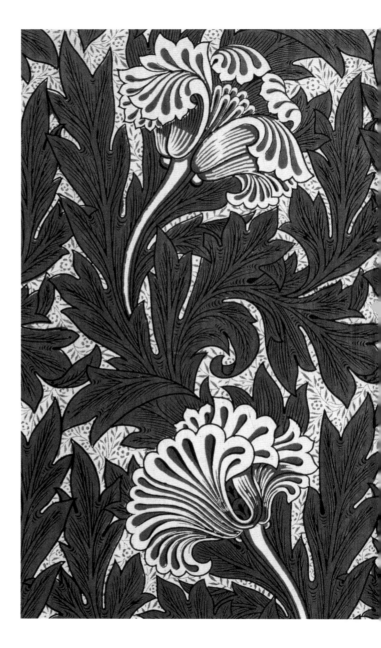

27. *Tulip* furnishing fabric, designed by William Morris and manufactured by Wardle & Co. for Morris & Co. Design registered 15 April 1875
Block-printed cotton
Victoria and Albert Museum, London
(V&A: T.629-1919)

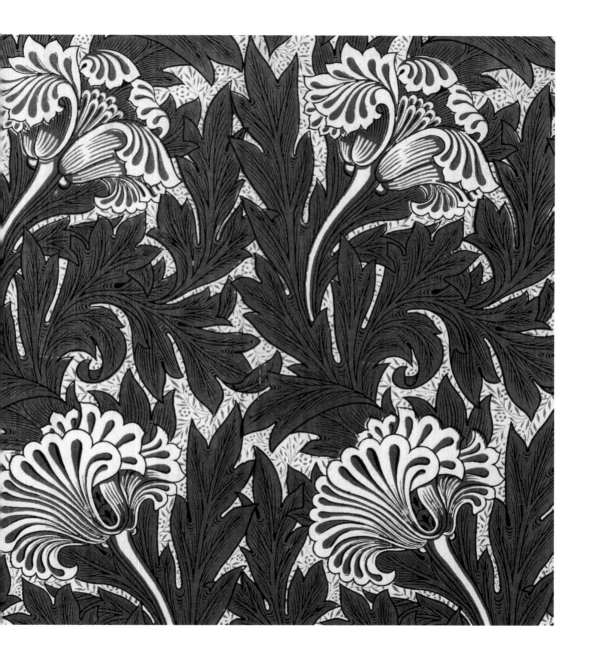

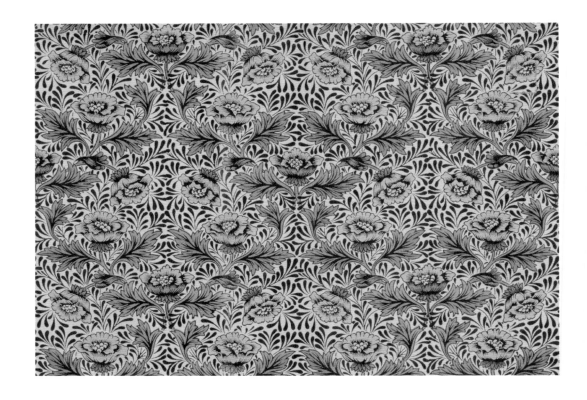

28. *Peony* furnishing fabric, designed
by Kate Faulkner and manufactured
by Wardle & Co. for Morris & Co.
Design registered 22 June 1877
Block-printed cotton
Victoria and Albert Museum, London
(V&A: T.587-1919)

These yellow peony flowers are arranged on a stylized
background in an almost square repeat. Morris favoured
larger patterns, and this arrangement is more characteristic
of the style of Kate Faulkner, an artist and designer and
the sister of Charles Faulkner, one of the founding partners
of Morris's first firm, Morris, Marshall, Faulkner & Co.
Besides wallpapers, Kate, together with her sister, Lucy,
also contributed to other areas of Morris & Co.'s production,
including embroideries and painted ceramics.

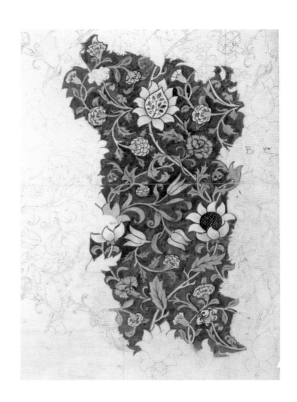

29. Design for *Evenlode*,
by William Morris
Designed March 1883,
Design registered 2 September 1883
Black chalk and watercolour
Victoria and Albert Museum, London
(V&A: E.543-1939)

On 3 March 1883 Moris wrote to his daughter May complaining of gout, for which Colchicum was then a common treatment:

> However I have been at work pretty hard & have made a new pattern which in honour of the occasion I ought to call "Colchicum": only as Colchicum is nothing less than crocus & I have stupidly omitted to put a crocus in, to avoid questions being asked I must fall back on a river and call it Evenlode.

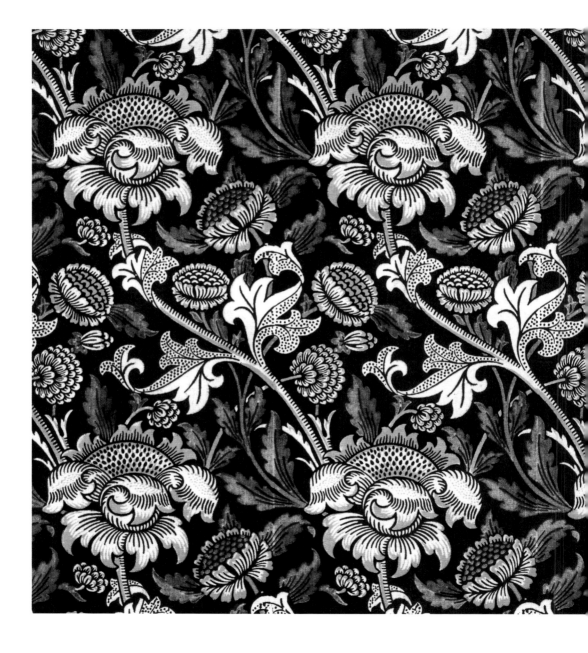

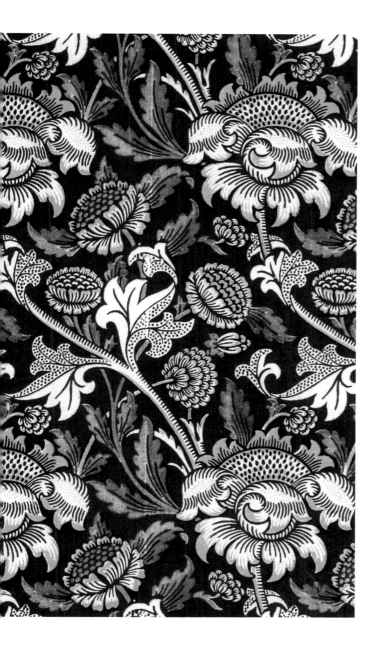

Wey (named after a Surrey river) is part of Morris's river tributaries series of textiles, which were exceptional for their scale and complex layers of diagonal pattern. They are the ultimate celebration of the exuberance of British flowers. In this design, large yellow sunflower-like flowers and smaller yellow marigolds criss-cross over each other, brightly contrasting against the dark indigo background.

30. *Wey* furnishing fabric, designed
by William Morris and manufactured
by Morris & Co.
Designed 1883
Indigo-discharged and
block-printed cotton
Victoria and Albert Museum, London
(V&A: T.49-1912)

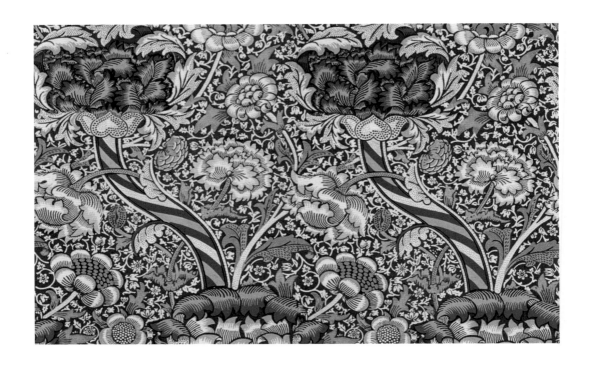

31. *Wandle* furnishing fabric, designed
by William Morris and manufactured
by Morris & Co.
Design registered 28 July 1884
Block-printed cotton
Victoria and Albert Museum, London
(V&A: T.45-1912)

The River Wandle ran through Morris's factory at Merton
and inspired this pattern. Morris wrote to his daughter
Jenny on 4 September 1883:

> I seem to have panic on our not having chintz blocks
> enough...one of them (I am working on it this afternoon)
> is such a big one that if it succeeds I shall call it Wandle:
> the connection may not seem obvious to you as the
> wet Wandle is not big, but small, but you see it will
> have to be very elaborate and so I want to honour
> our helpful stream.[41]

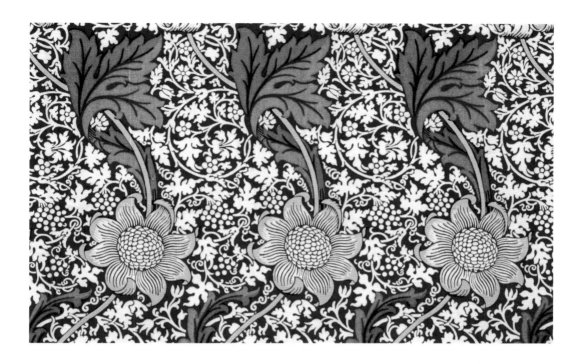

32. *Kennet* furnishing fabric, designed
by William Morris and manufactured
by Morris & Co.
Design registered 18 October 1883
Indigo-discharged and
block-printed cotton
Victoria and Albert Museum, London
(V&A: T.48-1912)

The River Kennet flows west from Wiltshire into the Thames.
In this pattern, yellow ribbons and sunflowers meander across
a background of bright white grape vines and blossoms,
silhouetted against the dark indigo background. The rows
of flowers are united by scrolling acanthus leaves – decorative
foliage that Morris used frequently in his patterns.

The River Cray is a tributary
of the River Darent, which
in turn is a tributary of the
Thames. *Cray* was the most
complex and expensive block-
printed fabric Morris ever
designed. The size of the
repeat meant that 34 different
woodblocks were required to
print one pattern repeat.

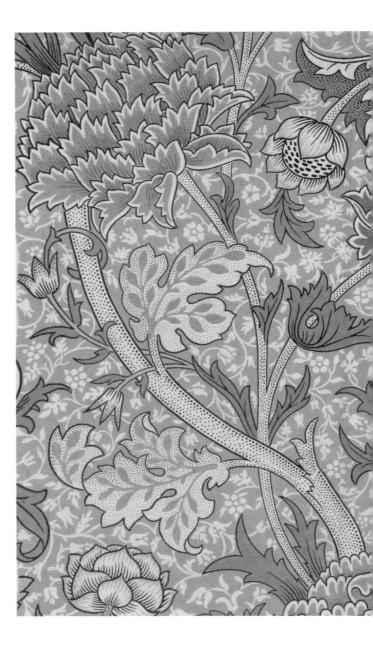

33. *Cray* furnishing fabric, designed
by William Morris and manufactured
by Morris & Co.
Designed 1884
Block-printed cotton
Victoria and Albert Museum, London
(V&A: T.34-1919)

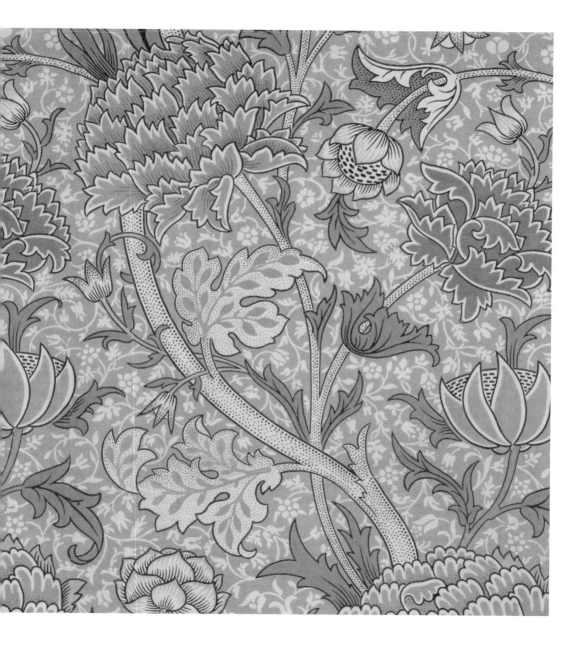

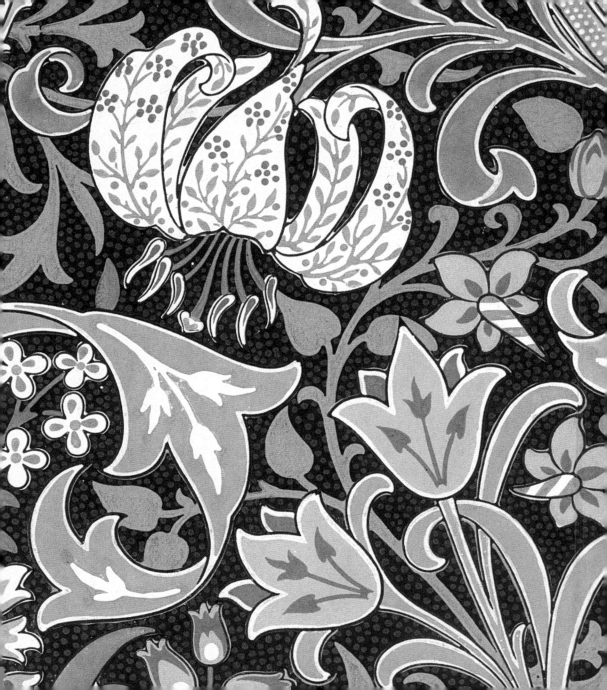

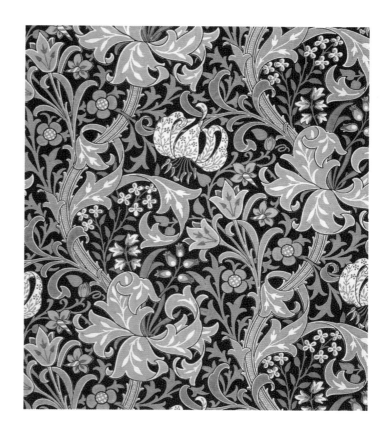

34. *Golden Lily* wallpaper, designed by
John Henry Dearle and manufactured
by Arthur Sanderson & Sons Ltd
Designed 1899, manufactured *c.*1955
Block-printed in distemper colours
on paper
Victoria and Albert Museum, London
(V&A: E.1407-1979)

In this floral wallpaper designed by Dearle, the bright white
lily petals are themselves ornamented with small pink flowers.
Following a decline in sales, Morris & Co. went into liquidation
in 1940. The wallpaper firm Arthur Sanderson & Sons bought
their design archive, wallpaper printing blocks and wallpaper
stock. Since then the firm has continued production of Morris
& Co. block-printed wallpaper designs.

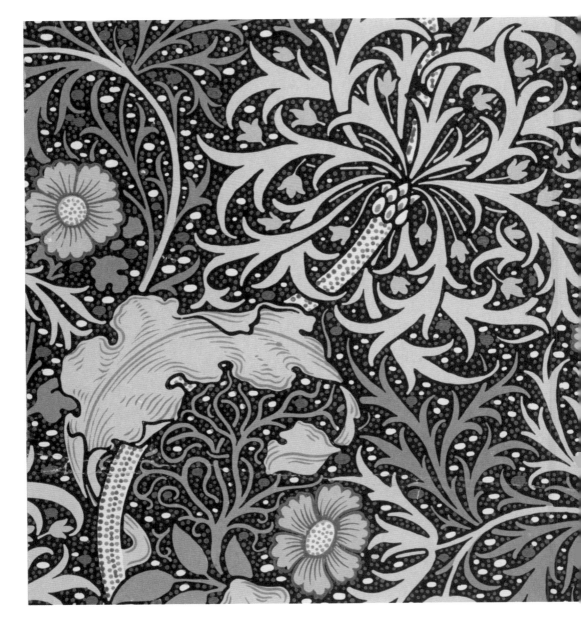

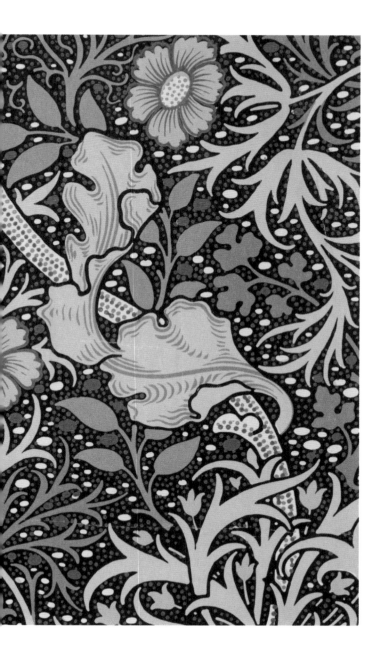

In this wallpaper, designed by Dearle, seaweed forms the scrolling mid-ground, against which tumble blue daisy-like flowers and larger spiky flower heads. The predominant blue and green colours evoke a coastal landscape, as does the white dotted background, which resembles barnacles. The dark blue background of this wallpaper is reminiscent of Morris's indigo-dyed textiles.

35. *Seaweed* wallpaper, designed by John Henry Dearle and manufactured by Arthur Sanderson & Sons Ltd
Manufactured *c*.1955
Block-printed in distemper colours on paper
Victoria and Albert Museum, London
(V&A: E.1418-1979)

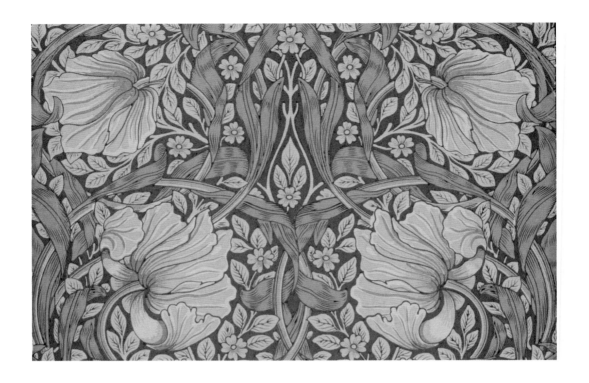

36. *Pimpernel* wallpaper, designed by
William Morris and manufactured by
Jeffrey & Co. for Morris & Co.
Design registered 29 February 1876
Block-printed in distemper
colours on paper
Victoria and Albert Museum, London
(V&A: Circ.280-1959)

The sensual rhythm of the tulip flowers and their curling
leaves is punctuated by small pimpernel flowers in this
wallpaper. The period between 1876 and 1883 was the most
prolific of Morris's career as a producer of wallpaper, and
during this time the spontaneity of his earlier patterns
gave way to a new formality. May Morris commented how
the wallpaper 'is specially adapted to rooms of dignified
proportion. Familiar to me in greens, as we had in the high
Adams dining-room at Hammersmith that my father
managed to "make the best of" with Rossetti pictures
and treasures from the East.'[42]

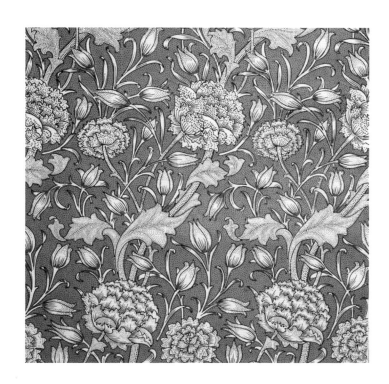

With their firm stems and variety of petals, tulips proved
endlessly adaptable in Morris's patterns. Smaller in scale than
its showy, high-bred cousins, the wild tulip is used here to form
the mid-ground, over which larger peonies meander. May Morris
wrote how the character of this design was 'all "Kelmscott"
to me: the peony and the wild tulip are two of the richest
blossomings of the spring garden at the Manor'.[43]

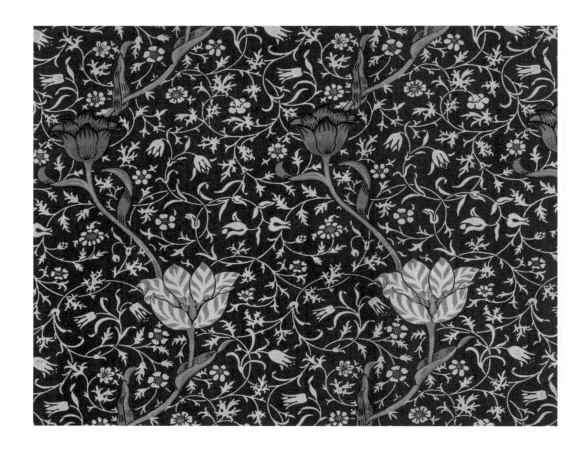

38. *Medway* furnishing fabric, designed
by William Morris and manufactured
by Morris & Co.
Design registered 21 September 1885
Indigo-discharged and block-printed
on cotton
Victoria and Albert Museum, London
(V&A: T.600-1919)

This pattern is one of Morris's tributaries series (named after
a river in Kent). It combines simple red tulips with a stylized
version of a variegated tulip, its petals ornamented with ripples
of pink. The relatively small size of the tulip heads and the
elegant leaf shape allow plenty of room for the mid-ground –
a pretty pattern of scrolling meadow flowers.

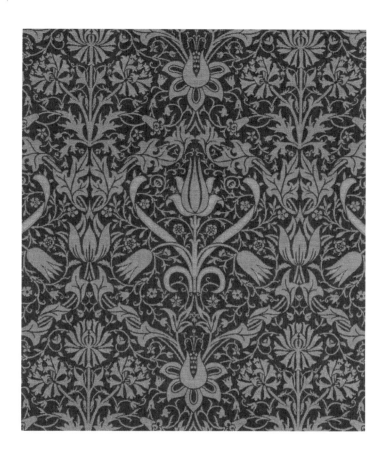

39. *Tulip and Net* furnishing fabric, designed by William Morris or John Henry Dearle and manufactured by Morris & Co.
Designed 1888–9
Jacquard-woven wool
Victoria and Albert Museum, London
(V&A: T.57-1934)

The blue tulips and lotuses and pink agapanthus flowers in this woven wool are flattened out, with little botanical detail or shading – only the recognizable profile remains. This treatment suits the medium of woven textile because the process of weaving makes it harder to achieve subtlety of detail compared to printed patterns.

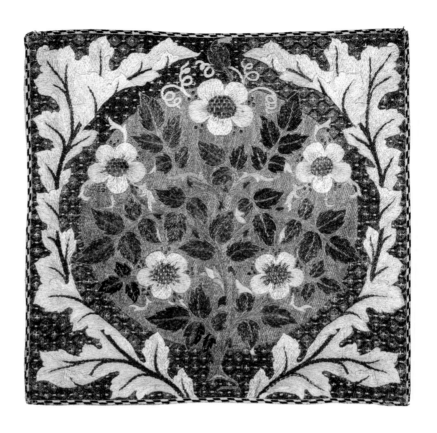

40. *Rose Wreath* cushion cover,
designed by William Morris and
embroidered by May Morris,
*c.*1890
Silks on linen
William Morris Gallery, London
(WMG: F435)

Rose Wreath was designed by William Morris and this
example was embroidered by May Morris as a cushion cover.
Here the whole rose bush is shown in a two-dimensional form,
surrounded by two wreaths of oak leaves. In one of his
lectures, Morris declared roses 'the queen of them all –
the flower of flowers'.[44]

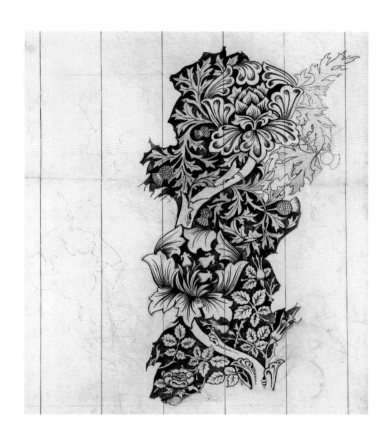

41. Design for *Rose and Thistle*,
by William Morris
Designed before June 1881
Watercolour and charcoal on paper
Victoria and Albert Museum, London
(V&A: E.293-1939)

Small roses alternate with bands of thistles to form the mid-ground of this pattern. The native wildflowers of Britain contrast here with the larger, more exotic flower heads that make up the foreground, and which have their origins in South Asian flower motifs. This is the first of Morris's patterns which follows a meandering 'branch' repeat; before this he used a symmetrical 'net' pattern for his printed designs.

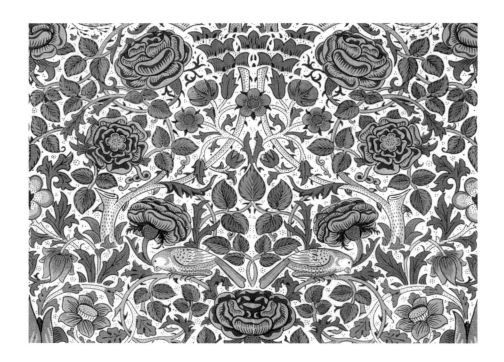

42. *Rose* furnishing fabric, designed by
William Morris and manufactured by
Morris & Co.
Design registered 8 December 1883
Block-printed cotton
Victoria and Albert Museum, London
(V&A: T.53-1912)

43. Design for *Rose*,
by William Morris, 1883
Pencil, pen and ink, watercolour
on paper
Victoria and Albert Museum, London
(V&A: E.1075-1988)

The original design (43) for this printed cotton features roses
shown from the side and head-on. Morris's use of shading,
dark outline and oblong petal shapes gives these flowers a
rather heavy impression, which is less naturalistic than his
other interpretations of one of his most admired flowers.

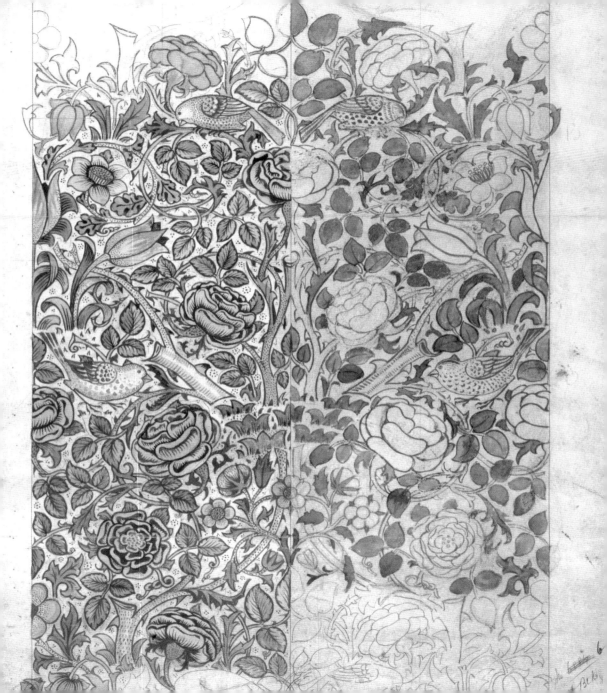

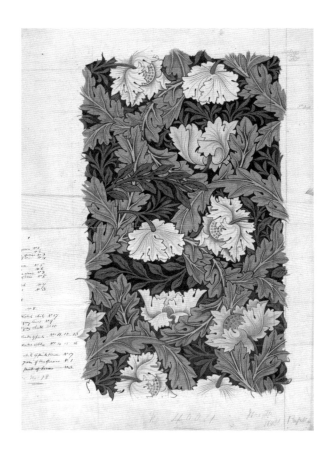

44. Design for *Wreath* wallpaper,
by William Morris, *c.*1880
Pencil, pen and ink, watercolour
and bodycolour on paper
Victoria and Albert Museum, London
(V&A: E.300-2009)

The large, frilly poppy flowers are almost submerged within the
dense green foliage in this wallpaper design. Morris's wallpapers
were manufactured by the London-based firm Jeffrey & Co.
Printed with distemper – a type of water-based paint – the
finished wallpapers achieved a chalky-like finish with subtle
natural colour variations.

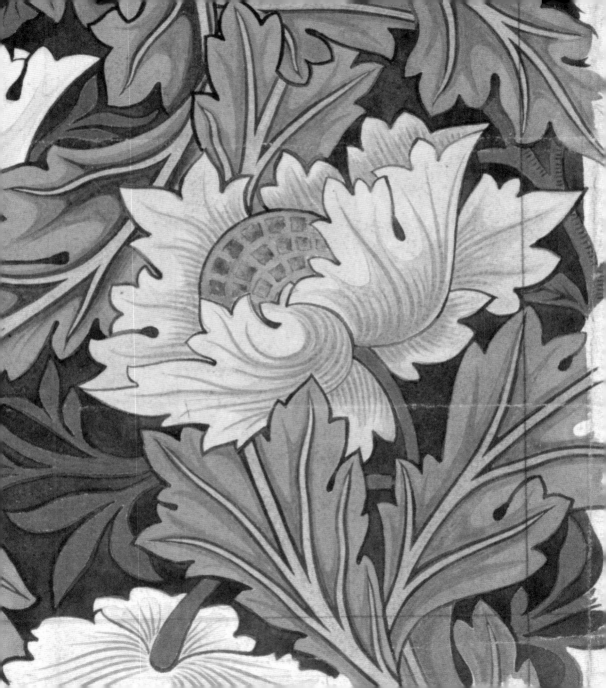

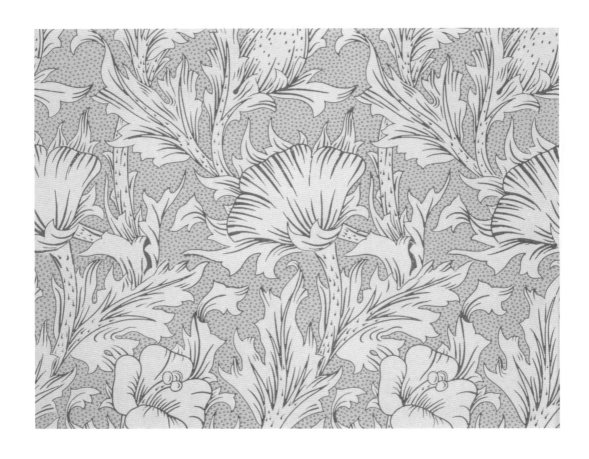

45. *Horn Poppy* wallpaper, designed
by May Morris and manufactured by
Jeffrey & Co. for Morris & Co.
Design registered 21 September 1885
Block-printed in distemper colours
on paper
Victoria and Albert Museum, London
(V&A: E.707-1915)

Hardier than the field poppy, the horned poppy thrives on
wild, windswept shingle beaches. It is so-named for its long,
curving seedpods that look like horns. May Morris frequently
used this distinctive flower in her embroideries as well as for
this wallpaper.

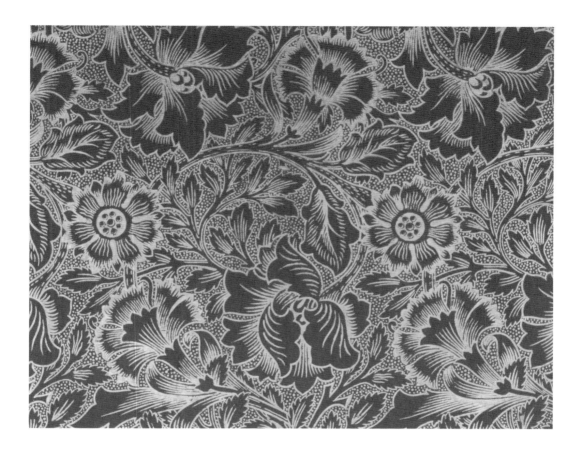

46. *Pink and Poppy* or *Poppy* wallpaper,
designed by William Morris and
manufactured by Jeffrey & Co. for
Morris & Co.
Designed 1880, manufactured 1881
Block-printed in silver and lacquer
on paper
Victoria and Albert Museum, London
(V&A: E.520-1919)

In this wallpaper the fragile, curling petals of the poppy
flowers droop downwards, while the marigolds, with their
frilly petals, and the pinks, seen here in profile, lift the
pattern upwards. In this unusual example from a Morris &
Co. sample book, the flowers are outlined in silver paint on
a red background. More typically the pattern was printed in
distemper with a darker outline on a pale background.

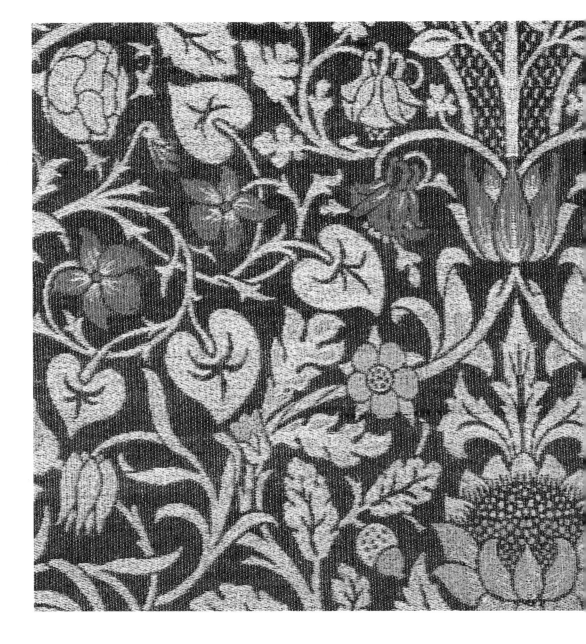

This woven fabric is patterned with a variety of small-scale flowers. Violets with their heart-shaped leaves, downward-facing pendant blossoms of columbine, teardrop-shaped fritillaries, roses and acorns surround larger sunflowers, which form the central point of this design.

47. *Violet and Columbine* furnishing fabric, designed by William Morris and manufactured by Morris & Co.
Design registered 7 April 1883
Woven wool and mohair
Victoria and Albert Museum, London
(V&A: T.11-1919)

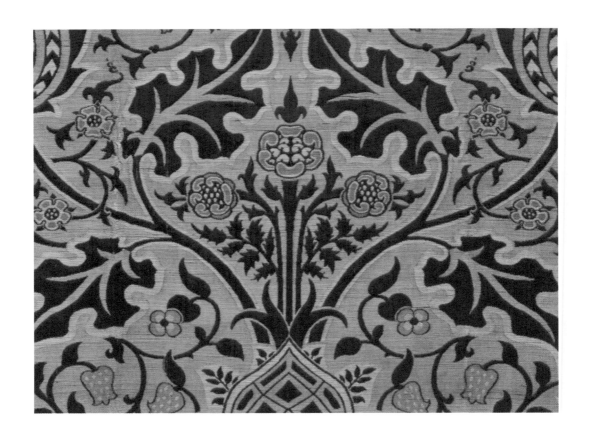

48. *Brocatel* furnishing fabric,
designed by William Morris and
manufactured by Morris & Co.
Designed *c.*1888
Woven silk
Victoria and Albert Museum, London
(V&A: Circ.125-1953)

In his lecture 'Making the Best of It' (1880), Morris warned
of the pitfalls of using red, 'unless it be helped by some beauty
of material, for, whether it tend toward yellow and be called
scarlet, or towards blue and be crimson, there is but little
pleasure in it, unless it be deep and full.'[45] The rich red
pattern of this woven silk is tempered by the small, cold,
pale blue flowers.

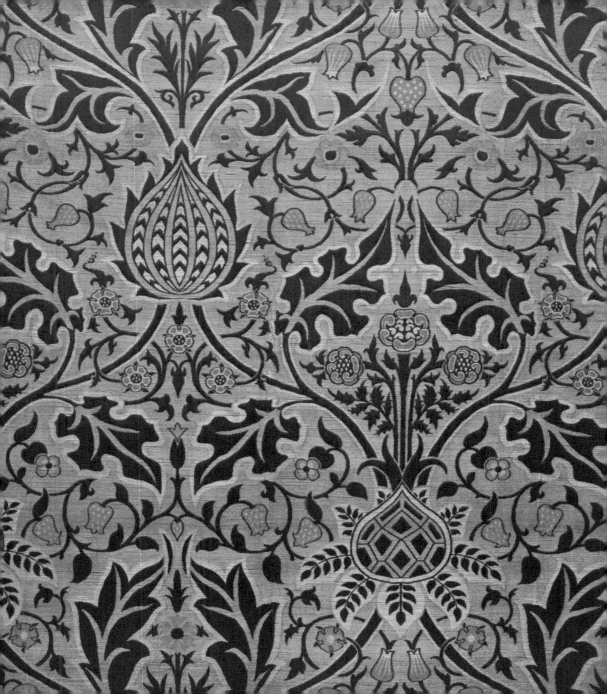

49. *African Marigold* printed cotton,
designed by William Morris and
manufactured by Wardle & Co.
Design registered 7 October 1876
Block-printed cotton
Victoria and Albert Museum, London
(V&A: Circ.42-1954)

Morris demanded exacting standards from his manufacturers.
On 8 February 1881 he wrote to Thomas Wardle:

> I am sorry to say that the last goods African marigold
> and red marigold sent are worse instead of better: they
> are in fact unsaleable; I should consider myself disgraced
> by offering them for sale: I laboured hard on making good
> designs for these and on getting the colour good: they
> are now so printed & coloured that they are no better
> than caricatures of my careful work.

Morris later took over the dyeing process of his fabrics at his
own factory, Merton Abbey.

Morris's lecture 'Making the Best of It' (1880) set out his
thoughts on garden design. His ideas on the best flowers were
closely related to those used in his floral patterns:

> though a late comer to our gardens, [the sunflower] is by
> no means to be despised, since it will grow anywhere, and
> is both interesting and beautiful, with its sharply chiselled
> yellow florets relieved by the quaintly patterned sad-
> coloured centre clogged with honey and beset with bees
> and butterflies.

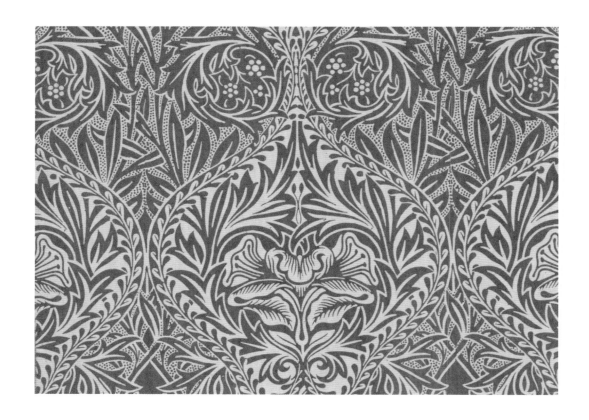

51. *Iris* furnishing fabric,
designed by William Morris and
manufactured by Wardle & Co.
Design registered 25 April 1876
Block-printed cotton
Victoria and Albert Museum, London
(V&A: T.45-1919)

Morris personally referred to this pattern as 'Flower-de-luce',
an archaic name for iris. The green monotone colourway was
used infrequently compared to other colours in his designs. This
may have resulted from his strong opinions about the futility
of directly copying patterns from nature, which extended to his
theories on colour application. In 1879 he lectured to students
of the Trades' Guild of Learning and the Birmingham Society of
Artists: 'if we try to outdo Nature's green tints on our walls we
shall fail, and make ourselves uncomfortable to boot'.[46]

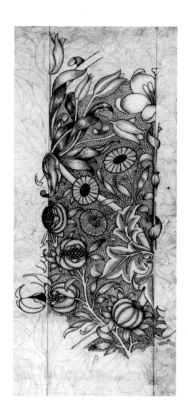

52. Design for *Lily and Pomegranate*
wallpaper, by William Morris, 1886
Watercolour, gouache, ink and pencil
on paper
William Morris Gallery, London
(WMG: A30)

This wallpaper design includes an abundance of lilies, tulips, gerbera-like flowers and pomegranates in rich colours. The dotted background was one of Morris's favourite devices, found in both his wallpapers and textiles, and is one which he enjoyed painting in his designs. When a friend asked him why he did not hand over such mechanical work to an assistant, Morris apparently replied: 'After taking all the trouble to draw it, do you think I'd be such a fool as not to do the dots?'

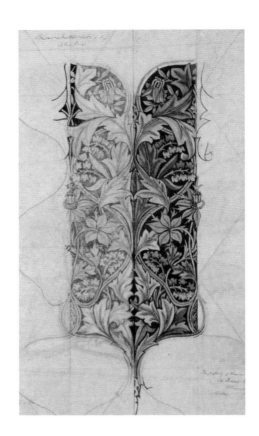

53. Design for *Columbine*,
by William Morris, 1876
Pencil, pen and ink, watercolour
and bodycolour on paper
Victoria and Albert Museum, London
(V&A: E.44-1940)

54. *Bluebell or Columbine* furnishing
fabric, designed by William Morris
and manufactured by Wardle & Co.
Designed 1876
Block-printed cotton
Victoria and Albert Museum, London
(V&A: Circ.44-1956)

'Be very shy of double flowers', Morris cautioned his students:
'choose the old columbine where the clustering doves are
unmistakable and distinct, not the double one, where they run
into mere tatters.' Morris's original design for this printed
cotton combines small pink bluebells with downward-facing
columbines in pink, and star-shaped columbine flowers in blue,
but in the final printed colourway (54) the blue columbines are
green and pink, camouflaged within the foliage.

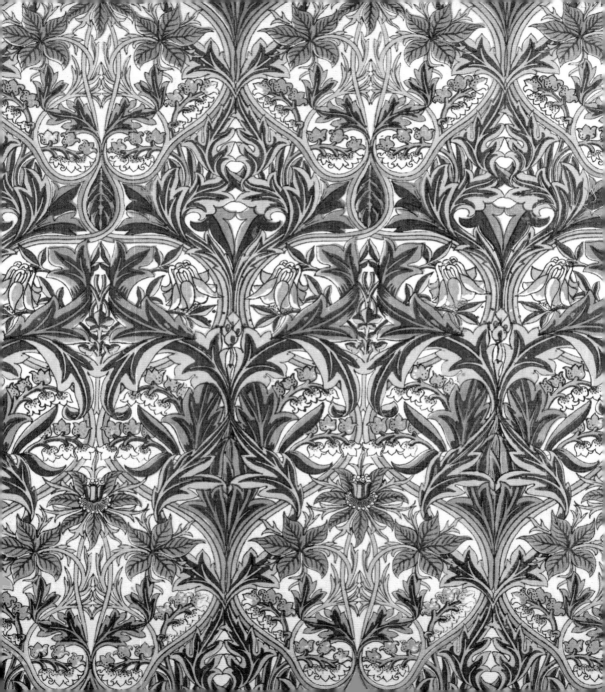

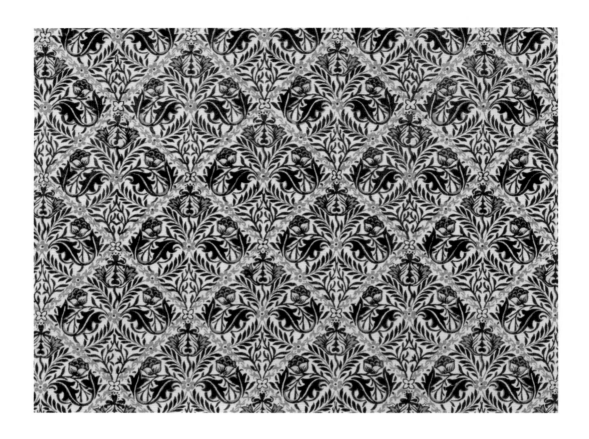

55. *Indian Diaper* furnishing fabric,
designed by William Morris and
manufactured by Wardle & Co.
for Morris & Co.
Designed before December 1875
Block-printed cotton
Victoria and Albert Museum, London
(V&A: Circ.45-1956)

The name of this small-scale printed pattern suggests
Morris's interest in textile patterns from India. The floriated
diaper pattern is formed by links of mustard yellow flowers,
with dark green leaves and flowers filling the diamond-
shaped spaces between the lines.

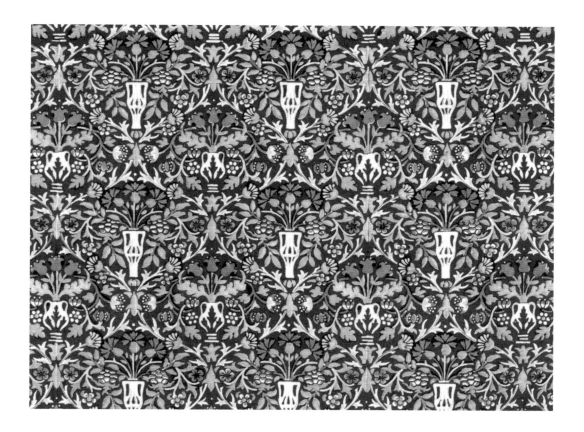

56. *Flowerpot* furnishing fabric,
designed by William Morris and
manufactured by Morris & Co.
Design registered 18 October 1883
Indigo-discharged and
block-printed cotton
Victoria and Albert Museum, London
(V&A: T.51-1919)

In this printed cotton, bunches of flowers stand tall in classical-shaped vases or flowerpots. This is a rare example of Morris inserting man-made objects into one of his designs for printed fabrics. The overall pattern is small in scale, and this was sometimes used by clients as dress fabric.

Of the same scale as *Indian Diaper* (55), *Little Chintz* was another Morris-designed pattern inspired by the small, repeating block-printed flower motifs that were characteristic of nineteenth-century imported textiles from India. In this soft-toned pattern, pink and red pomegranates are surrounded by small pink flowers and bluey-grey foliage.

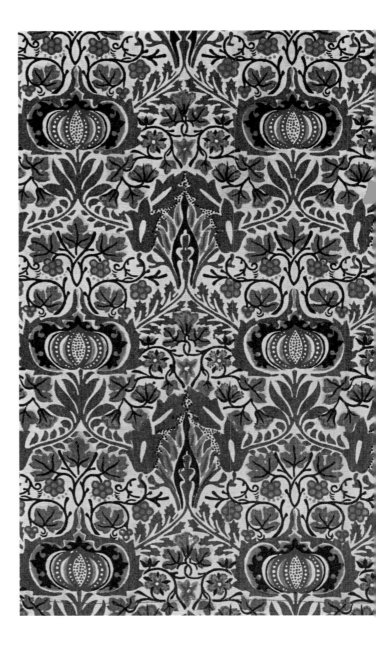

57. *Little Chintz* furnishing fabric, designed by William Morris and manufactured by Thomas Wardle & Co.
Manufactured 1876
Block-printed cotton
Victoria and Albert Museum, London
(V&A: T.40-1919)

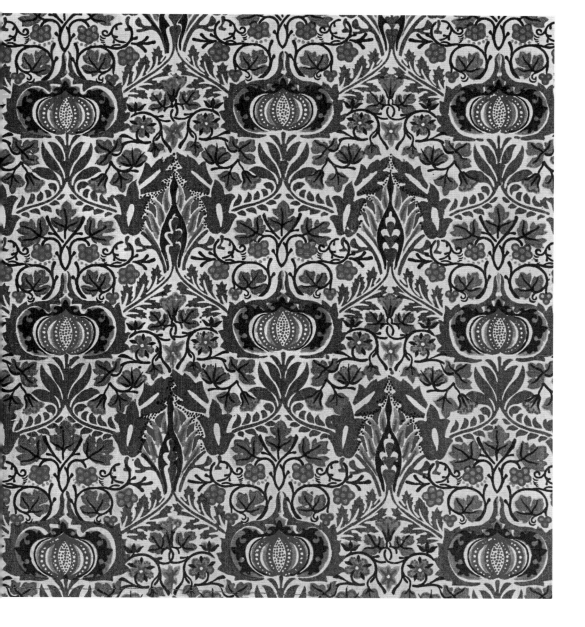

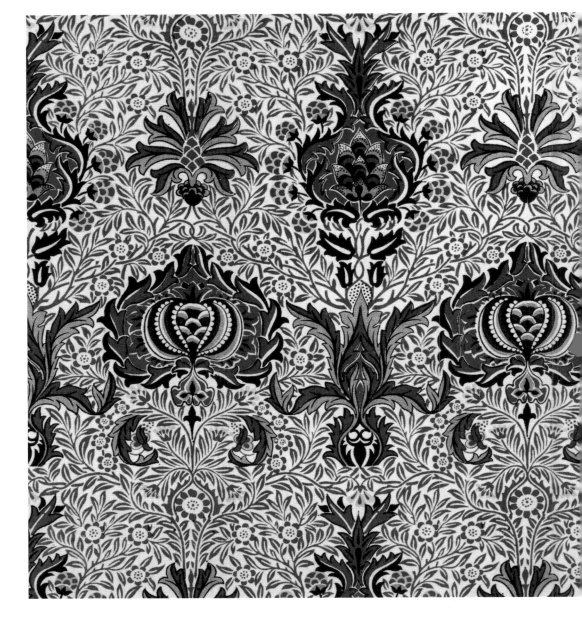

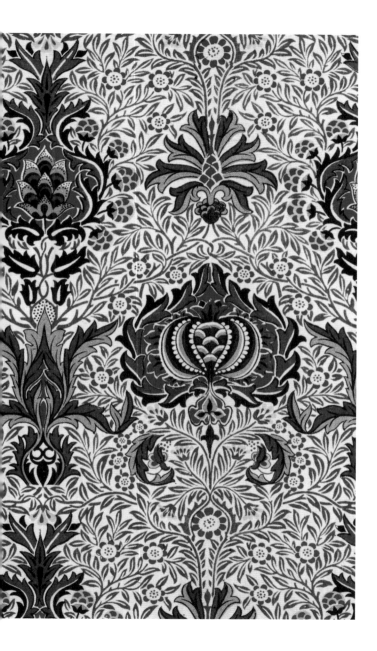

The contrasting red, blue, brown and dark green of this pattern reveal Morris experimenting with stronger natural colours, a result of his investigations into the use of the natural dyes seen in Indian textiles. As in *Little Chintz* (57), designed the previous year, Morris used the pomegranate fruit as the central focus of the pattern.

58. *Pomegranate* furnishing fabric, designed by William Morris and manufactured by Morris & Co. Design registered 22 June 1877 Block-printed cotton Victoria and Albert Museum, London (V&A: T.592-1919)

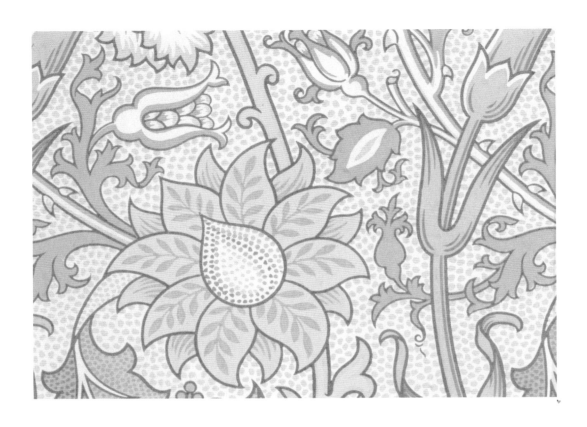

59. *Pink and Rose* wallpaper, designed
by William Morris and manufactured
by Jeffrey & Co. for Morris & Co.
Designed *c.*1890
Block-printed in distemper
colours on paper
Victoria and Albert Museum, London
(V&A: E.708-1915)

Large pinks, from the same family as carnations, dominate
this pattern. The distinctive flower shape was a favourite motif
used in Ottoman decoration and was familiar to Morris, who
owned collections of Ottoman textiles and ceramics. Its use here,
alongside stylized palmette flower forms with teardrop shapes
at their centres, creates an overall effect that is reminiscent of
Middle Eastern pattern design.

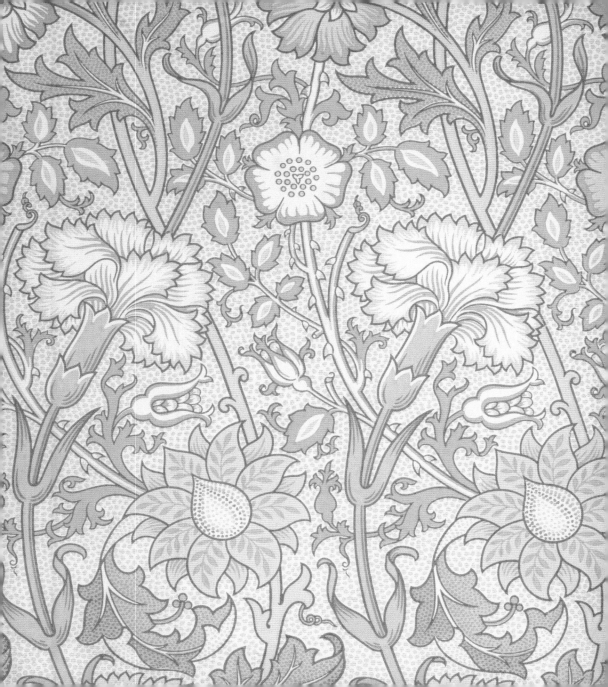

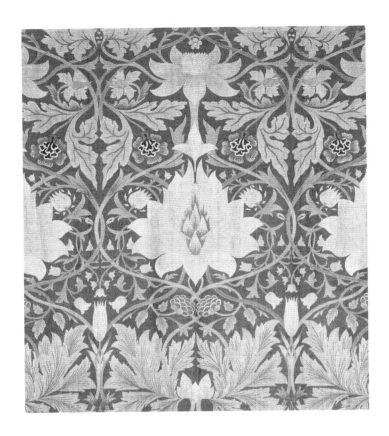

60. *Lotus* embroidered wall hanging,
designed by William Morris and
embroidered by Margaret Beale and
her daughters
Designed 1875–80,
embroidered 1880–91
Silk on canvas
Victoria and Albert Museum, London
(V&A: T.192-1953)

The overall floral design of this embroidered panel is crowned
with a lotus flower, a floral motif most closely associated with
South and South-East Asian design traditions. The panel was
embroidered by members of the Beale family, wealthy clients
of Morris & Co. living in Holland Park, London. In 1894 the
family moved to Standen in Sussex, a large house designed by
Philip Webb and with interior decoration by Morris & Co.

61. Design for *Redcar* carpet,
by William Morris, *c.*1881
Pencil, watercolour, bodycolour
and Chinese white on paper
Victoria and Albert Museum, London
(V&A: E.144-1919)

In 1881, Hugh Bell commissioned a carpet for an extension
of his Yorkshire home, Red Barns, in Coatham near Redcar.
This original drawing shows flowers in pastel shades on a light
brown background. Many of Morris's first experiments in carpet
production were produced using similar colour schemes, inspired
by the gentle tones of traditional Chinese carpets. Later, Morris
favoured strong red and indigo colours found more typically in
Middle Eastern carpet design.

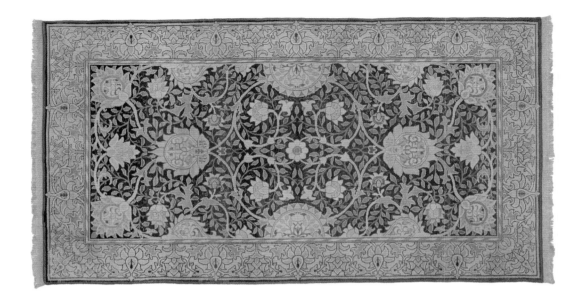

62. *Carbrook* carpet, designed by
William Morris and manufactured
by Morris & Co.
Designed 1879–81, made 1883
Hand-knotted woollen pile, cotton
warp and jute binding threads
Victoria and Albert Museum, London
(V&A: Circ.458-1965)

The original carpet on which this example was based no longer
survives. The original was designed by Morris between 1879
and 1881 for a property called Carbrook, and was later reused
for a number of carpets, including this one, which was made for
the Antiquity Room of Morris's friends the Ionides, who lived
at 1 Holland Park, London. The pale colouring of the borders
and the palmette shapes, roses and sunflowers in the central
design may have been chosen to complement the silvery tones
of the Morris & Co. designed interior.

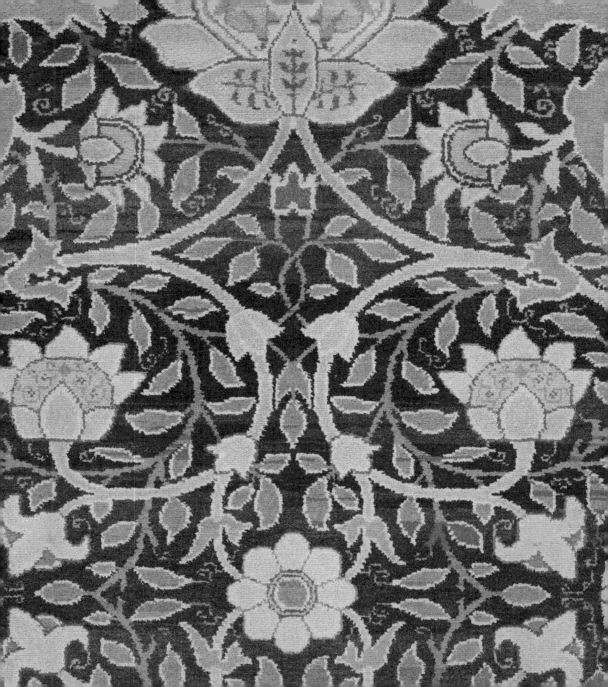

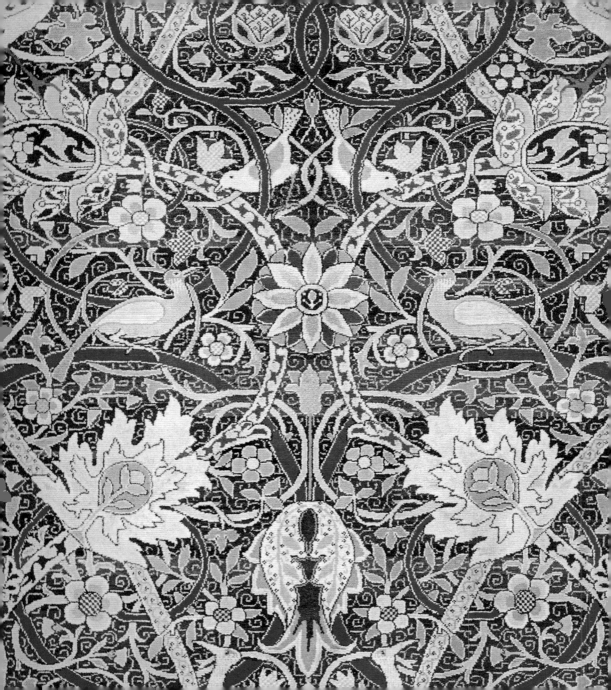

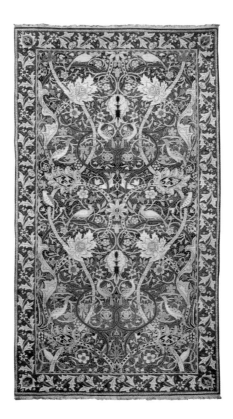

63. *Bullerswood* carpet, designed by William Morris and John Henry Dearle
Designed and made 1889
Hand-knotted woollen pile, cotton warp and jute binding threads
Victoria and Albert Museum, London
(V&A: T.31-1923)

As a result of his study of historic carpets from Iran and Turkey, Morris's carpets became increasingly larger and more sophisticated. In this carpet, commissioned for Bullerswood, the Kent home of wool trader John Sanderson, he used an overall network of trailing leaves, with repeated medallions, palmettes and birds. Although Morris believed that Persian carpets were the greatest ever made, he adopted the coarser Turkish (Ghiordes) knot for his own hand-knotted carpet manufacture, which gave a more pixelated finished design.

64. *Utrecht Velvet* furnishing fabric
Design discovered and revived
by William Morris, and probably
manufactured by J. Aldam Heaton for
Morris & Co. from *c*.1871
Stamped mohair plush
Victoria and Albert Museum, London
(V&A: T.210-1953)

This floral stamped velvet is a copy of a traditional seventeenth-century Dutch design. Practical and hard-wearing, the fabric was used by Morris & Co. for the upholstery on a number of the firm's range of armchairs. It was also used in decorative schemes, including for one of the first-class cabins on the doomed ocean liner *Titanic*.

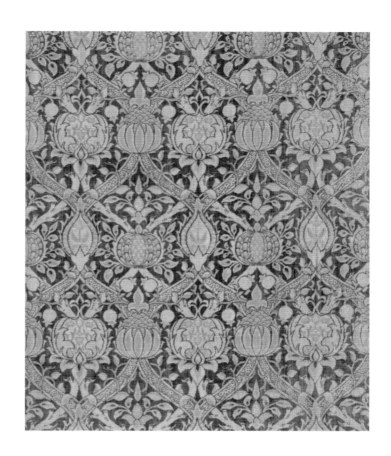

65. *Granada* furnishing fabric,
designed by William Morris and
manufactured by Morris & Co.
Designed 1884
Woven silk velvet brocaded
with gold thread
Victoria and Albert Museum, London
(V&A: T.4-1919)

Granada is so named because it recalls the Spanish and Italian
brocaded velvets of the sixteenth century. The fabric, which
required a specially constructed loom, took so long to weave
that it was never put into commercial production. Only 20 yards
(about 18 m) were produced in 1884, at a prohibitive cost of £10
per yard.

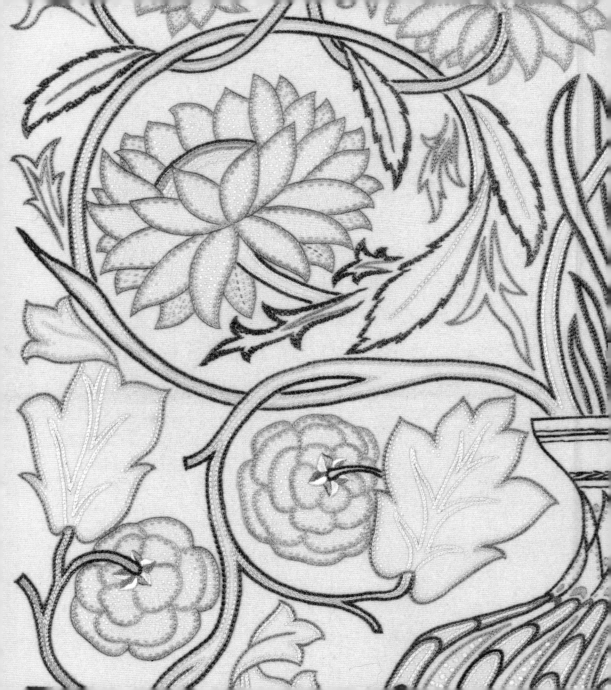

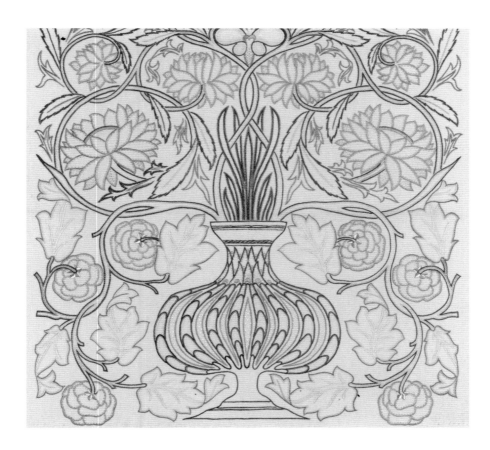

66. *Flowerpot* firescreen or cushion
cover, designed by William Morris
and embroidered by May Morris
Designed *c.*1878–80, made 1890–1900
Silks on wool
Victoria and Albert Museum, London
(V&A: T.68-1939)

Morris based the design of this embroidery on two Italian
seventeenth-century lacis-work panels acquired by the South
Kensington Museum in 1875. Lacis is a handmade net onto
which a design is darned. May Morris's interpretation of her
father's design uses mainly outlines of chain stitch in pastel
shades, highlighted with dots of pale cream thread on the
flower petals.

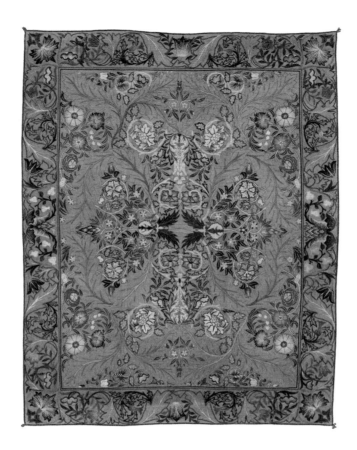

67. *Acanthus* bed cover, designed
by William Morris and worked by
May Morris and others
Designed *c*.1880, made *c*.1900–10
Coloured silk thread on woollen felt
cloth; edged with silk cord
Victoria and Albert Museum, London
(V&A: T.66-1939)

Acanthus was one of William Morris's most popular
compositions. Under May's leadership the Morris & Co.
embroidery department produced a number of variations in
different colourways. This example is embroidered on blue felt
and is from May's personal collection. It exemplifies her skilful
use of colour, with scrolling leaf shapes in tones of blue, and
carnations, fritillaries and lilies in rich reds and purples.

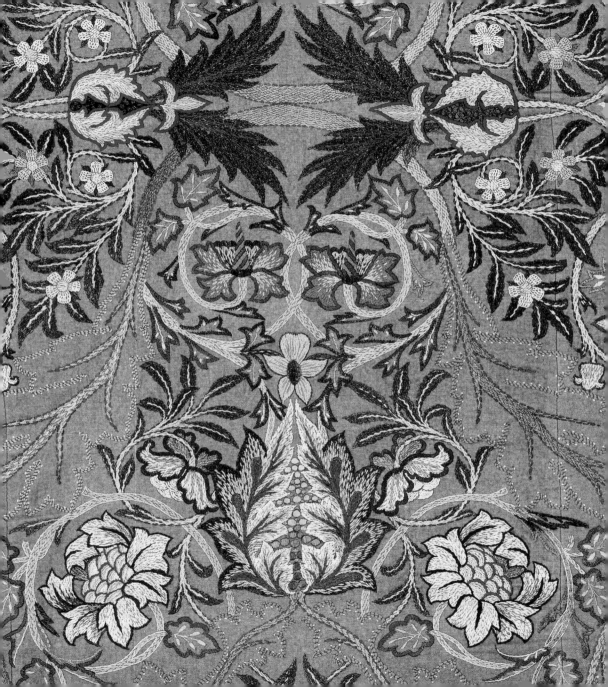

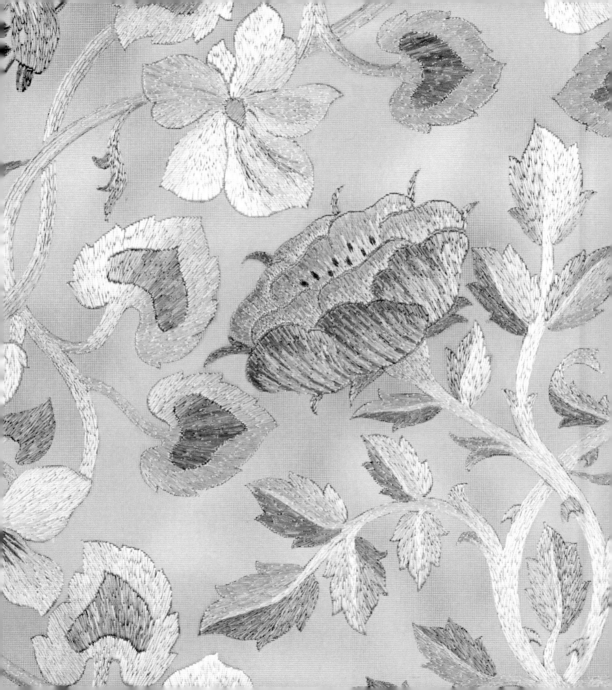

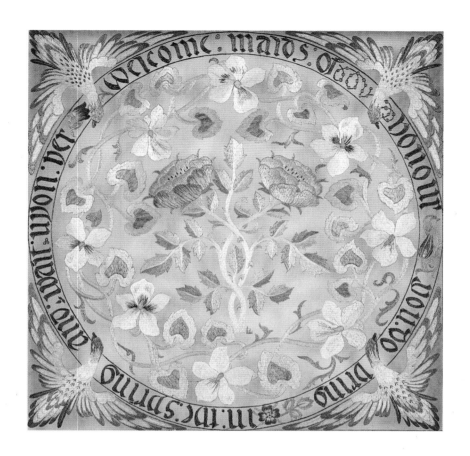

68. *Maids of Honour* embroidered
panel, designed and embroidered by
May Morris, c.1890s
Coloured silks on silk net
William Morris Gallery, London
(WMG: F368)

In this embroidery, May Morris illustrates the violets and
roses featured in the poem 'To Violets' by the seventeenth-
century poet Robert Herrick. The first verse, beginning
'Welcome, maids of honour', encircles the main design.
The combination of flowers and birds in subtle colours makes
this one of May's most harmonious and elegant designs.

The Orchard was William Morris's first attempt to design a figurative tapestry. It depicts an array of fruit trees with their harvest ready for gathering, including apples, grapes, olives and pears, behind a row of figures in medieval-style dress. At their feet is an array of wildflowers – red poppies, white tulips, and blue pansies and harebells. The figures are holding a scrolling banner with a poem composed by Morris, written especially for the tapestry, and celebrating the bounty of the orchard and the rhythm of the seasons.

69. *The Orchard* tapestry, designed by William Morris and John Henry Dearle and made by Morris & Co.
Made 1890
Woven in wool, silk and mohair on a cotton warp
Victoria and Albert Museum, London
(V&A: 154-1898)

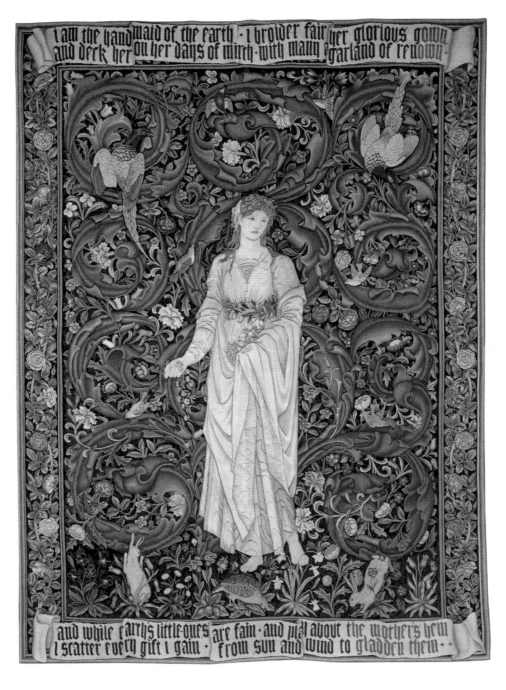

I am the handmaid of the earth · I broider fair her glorious gown
and deck her on her days of mirth · with many a garland of renown

and while earths little-ones are fain · and play about the mother's hem
I scatter every gift I gain · from sun and wind to gladden them

70. *Flora* tapestry, designed by
Edward Burne-Jones and William
Morris and made by Morris & Co.
Designed 1882–3, made 1888–5
Woven in wool on linen
The Whitworth, The University
of Manchester
(Whitworth: T.8353)

Flora, the goddess of abundance and personification of summer,
stands here immersed in a floral background, inspired by the
medieval decorative technique known as millefleurs (thousand
flowers). Ribbons of William Morris's verse adorn the top and
bottom of the design: 'I am the handmaid of the earth /
I broider fair her glorious gown / And deck her on her days
of mirth / With many a garland of renown. / And while Earth's
little ones are fain / And play about the Mother's hem / I scatter
every gift I gain / From sun and wind to gladden them.'

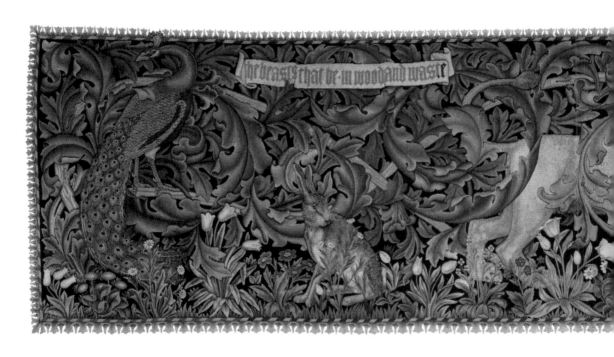

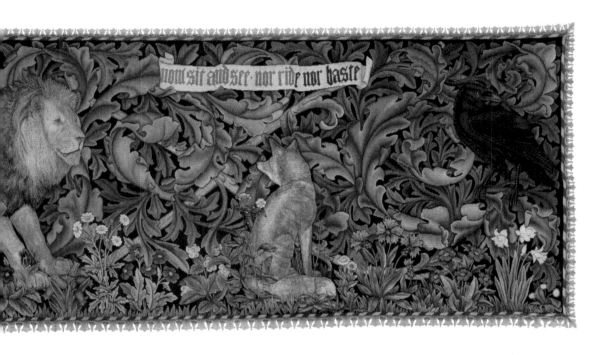

The banner in the tapestry reads: "now sit and see · nor ride nor baste"

71. *The Forest* tapestry, designed by
William Morris, Philip Webb and John
Henry Dearle, and made by Morris & Co.
Designed 1886, made 1887
Woven in wool and silk on a
cotton warp
Victoria and Albert Museum, London
(V&A: T.111-1926)

The Forest is one of Morris's greatest achievements in the field
of tapestry design. The animals, drawn by Philip Webb, are
surrounded by Morris's trademark scrolling acanthus leaves
and spring flowers.

And kissing foot, and kissing knee
Passed on to the forgetful sea—
Yet with naught true thou wilt me greet.

And thou, that men called by my name
O helpless one, hast thou no shame
That thou must even now seem the same
As while agone, as while agone,
When thou and She stood close alone,
And hands and lips and tears did meet.

Grow weak and pine he down to die
O body in thy misery
Because short time and sweet goes by
O foolish heart, how weak thou art!
Break, break, because thou needs must part
From thine own Love, from thine own Sweet

72. *A Book of Verse* illuminated
manuscript, written and decorated
by William Morris, with drawing in
gouache by Edward Burne-Jones and
miniatures by Charles Fairfax Murray,
some after designs by George Wardle
Made 1870
Vellum binding, tooled in gold, ink
and gilt on paper
Victoria and Albert Museum, London
(V&A: MSL/1953/131)

Morris's love of medieval texts inspired his determination to master the arts of illumination and calligraphy. In 1870 he presented this illuminated manuscript of verse to his friend Georgiana Burne-Jones. The pages are decorated by Morris in gouache and gold, with floral foliage creeping over the page, almost submerging the text which it surrounds.

73. Design for a large border for
The Works of Geoffrey Chaucer, by
William Morris
Printed 1896
Ink and Chinese white on paper
Victoria and Albert Museum, London
(V&A: D.1552-1907)

The Kelmscott Chaucer was the most ambitious book Morris
ever printed; it took four years to produce and was only
finished just before his death. But it was a labour of love, the
culmination of Morris and Burne-Jones's long friendship and
their admiration for medieval books and manuscripts. Morris
designed the typeface, decorative initials and page layout;
Burne-Jones designed the illustrations.

74. Trial proof for *The Story of the
Glittering Plain*, by William Morris
Printed by the Kelmscott Press, 1894
Black ink printed on paper
William Morris Gallery, London
(WMG: K134)

Morris's decorative book borders show how he reused the
distinctive botanical motifs from his designs for printed textiles
and wallpapers, turning them into monochromatic printed
decoration for the page.

THE LOVE-LYRICS AND SONGS OF PROTEUS.

SONG. LOVE ME A LITTLE.

LOVE me a little,
love me as thou wilt,
Whether a draught
it be of passionate
wine
Poured with both
hands divine,
Or just a cup of
water spilt
On dying lips and mine.
Give me the love thou wilt,
The Purity, the guilt,
So it be thine.

2.

Love me a little. Let it be thy cheek
With its red signals, that were dear to kiss;
Or, if thou mayest not this,
A finger-tip my own to seek
At night-fall when none guess.
Eyes have the wit to speak,
And sighs send messages:
Even give less.

3.

Love me a little. Let it be in words
Of happy omen heralding thy choice,

*75. Love Lyrics and Songs with Love –
Sonnets of Proteus*, designed by
William Morris
Printed by the Kelmscott Press, 1892
Red and black ink printed on paper
William Morris Gallery, London
(WMG: K1005)

Morris designed three typefaces for the books printed at the
Kelmscott Press. He also decorated illuminated capital letters,
reminiscent of medieval book design, and made distinctive
through his own flower motifs and foliated pattern.

Notes

1 Mackail 1922, p. 352

2 From a lecture, *Art and the Beauty of the Earth*, delivered 13 October 1881 before the Wedgewood Institute at the Town Hall, Burslem

3 *News from Nowhere* is Morris's utopian novel, in which the main character, William Guest, wakes one morning to find himself in the year 2102 and discovers a society that has changed beyond recognition into a pastoral paradise.

4 Letter to the *Daily Chronicle* supporting a campaign to preserve Epping Forest, 22 April 1895, in Kelvin vol. 4, 1996, p. 268

5 From a lecture, 'Some of the Minor Arts of Life' (later published under the title 'The Lesser Arts of Life'), delivered 1877, published 1882

6 Morris 1936, vol. 1, p. 37

7 A letter from William Morris to his mother, 11 November 1855 (now in the William Morris Gallery, London), reveals how Morris broke the news of the change of his intended career path from clergyman to artist.

8 Letter to Andreas Scheu, 15 September 1883, in Kelvin vol. 2, 1987, p. 228

9 The original partners were William Morris, Edward Burne-Jones, Philip Webb, Gabriel Dante Rossetti, Ford Madox-Brown, Charles Faulkner, Peter Paul Marshal and Arthur Hughes (Hughes resigned shortly after).

10 Marsh, *William Morris & Red House*, London, 2005, p. 56

11 From a lecture, 'Some Hints on Pattern-Designing', delivered 10 December 1881

12 For this wallpaper Morris directly replicated a daisy motif from a wall hanging illustrated in the fifteenth-century illuminated manuscript *Froissart's Chronicles.*

13 Letter to Charles Faulkner, 17 May 1871, in Kelvin vol. 1, 1984, p. 133. Water Eaton Manor is a sixteenth-century manor house in rural Oxfordshire.

14 Mackail 1899, vol. 1, pp. 236–8

15 Ibid., p. 230

16 From a lecture, 'Making the Best of It', delivered 1880

17 'Some Hints on Pattern-Designing', 1881

18 Ibid.

19 Ibid.

20 Ibid.

21 The final version of this textile was printed successfully ten years after it was designed, after Morris constructed an indigo vat at his Merton Abbey factory.

22 'Making the Best of It', 1880

23 Before the move to Merton Abbey, Morris & Co. products were made at their premises in 26 Queen's Square or outsourced to companies such as Wardle & Co. in Leek.

24 A visitor to Merton at the end of April 1882 described how Morris gave them gifts of 'marsh marigolds, wallflowers, lilac, and hawthorn'; Mackail 1899, vol 2, p. 59.

25 Morris 1973, vol. 1, p. 377

26 Ibid., p. 378

27 Morris's essay 'A Factory As It Might Be' (1884), published as a pamphlet later that same year, sets out a vision for how beautiful factories would act as centres of education and creativity.

28 In 1902, C.R. Ashbee and some 100 followers settled in Chipping Campden, bringing with them the ethos of the Guild of Handicraft originally set up by Ashbee at London's Toynbee Hall in 1888.

29 William Lethaby was an architect and art historian. Quoted in Morris 1936, vol. 1, p. 38

Picture Credits

30 'Making the Best of It', 1880

31 Morris 1893

32 Morris 1936, vol. 1, p. 37

33 'Making the Best of It', 1880

34 From a lecture, 'The History of Pattern-Designing', delivered 1879

35 Carey 2017, p. 209

36 For a more detailed study of the development of Morris & Co. embroidery see Parry 2013, pp. 14–41

37 As Parry has identified, although Morris is frequently attributed, the floral decoration was more often Dearle's contribution; ibid., p. 132.

38 Morris 1936, vol. 1, p. 37

39 Ibid.

40 'Some Hints on Pattern-Designing', 1881

41 Kelvin vol. 2, 1987, p. 223

42 Morris 1936, vol. 1, pp. 40–41

43 Ibid., p. 36

44 'Making the Best of It', 1880

45 Ibid.

46 Ibid.

Selected Bibliography

Works by William Morris

'The Lesser Arts of Life', 1877, published in 1882

'The History of Pattern-Designing', 1879

'Making the Best of It', 1880

'Some Hints on Pattern-Designing', 1881

William Morris, *News From Nowhere; or, An Epoch of Rest*, originally published in *The Commonweal*, January–October 1890; reprinted by Roberts Brothers, Boston, 1890; first English edition by Reeves and Turner, 1891

Other publications

Derek Baker, *The Flowers of William Morris* (Barn Elms, London, 1996)

Stephen Calloway and Lynn Federle Orr, *The Cult of Beauty: The Aesthetic Movement 1860–1900* (V&A Publications, London, 2011)

Moya Carey, *Persian Art: Collecting the Arts of Iran for the V&A* (V&A Publications and Thames & Hudson, London, 2017)

Lynn Hulse (ed.), *May Morris: Art & Life – New Perspectives* (The Friends of the William Morris Gallery, London, 2017)

Norman Kelvin (ed.), *The Collected Letters of William Morris*, 4 vols (Princeton University Press, 1984–96)

Carien Kremer and Anna Mason, *William Morris in 50 Objects* (William Morris Gallery, London, 2012)

Fiona MacCarthy, *William Morris: A Life for Our Time* (Faber & Faber, London, 1994)

Fiona MacCarthy, *Anarchy & Beauty: William Morris and his Legacy 1860–1960* (National Portrait Gallery, London, 2014)

J.W. Mackail, *The Life of William Morris*, 2 vols (Longmans Green & Co., London, 1899); 1 vol. 1922

Jan Marsh, *William Morris & Red House* (National Trust, London, 2005)

Anna Mason et al., *May Morris: Arts & Crafts Designer* (Thames & Hudson, London, 2017)

May Morris, *Decorative Needlework* (Joseph Hughes, London, 1893; new edn, Dodo Press, London, 2010)

May Morris, *William Morris: Artist, Writer, Socialist*, 2 vols (Basil Blackwell, Oxford, 1936)

May Morris, *The Introductions to the Collected Works of William Morris*, 2 vols (Oriole Editions, New York, 1973; reprinted from *The Collected Works*, 24 vols, Longmans, London, 1910–15)

Linda Parry, *William Morris Textiles* (Weidenfield & Nicholson, London, 1983; 2nd edn, V&A Publications, London, 2013)

Linda Parry (ed.), *William Morris* (Philip Wilson in association with the Victoria and Albert Museum, exh. cat., London, 1996)

William S. Petterson, *The Kelmscott Press: A History of William Morris's Typographical Adventure* (Clarendon Press, Oxford, 1991)

Tessa Wild, *William Morris and His Palace of Art: Architecture, Interiors and Design at Red House* (Philip Wilson, London, 2018)

Acknowledgments

Thanks to all my colleagues
at the William Morris Gallery,
London who supported me during
the course of writing this book.
Special thanks are due to my former
colleagues, Carien Kremer and Anna
Mason, whose encouragement and
enthusiasm for Morris has been an
inspiration. In 2018 Linda Parry
donated her research archive to
the William Morris Gallery, which
proved invaluable for my research.
I would also like to acknowledge
Julia Dudkiewicz and Thomas Kirby
for their helpful suggestions and
Sarah Mercer for her photography.

I would like to thank all those
at the V&A and Thames & Hudson
who helped with the production
of this book, in particular Hannah
Newell for her helpful advice and
input, Katy Carter who expertly
edited the text and Isabel Roldán for
her book design. Thank you to John
and Tessa Bain for casting their eyes
over the text, and lastly to Tan, for
his unfailing patience and support.

Author's Biography

Rowan Bain is Senior Curator at
the William Morris Gallery and
was formerly assistant curator at the
Victoria and Albert Museum. She is
the co-author of *May Morris: Arts &
Crafts Designer* and has contributed
to various articles on Morris and the
collection. Other publications include
*Be Magnificent: Walthamstow School
of Art 1957–1967* and contributions
to *Shoes: Pleasure & Pain.*

Cover image: Detail from *Rose* furnishing fabric, 1883 (p. 92)
Opposite title page: Detail from *Seaweed* wallpaper, *c.*1955 (p. 84)
Opposite contents page: *The Forest* tapestry, 1887 (p. 134)

First published in the United Kingdom in 2019 by
Thames & Hudson Ltd, 181A High Holborn, London WC1V 7QX,
in association with the Victoria and Albert Museum, London

First published in the United States of America in 2019 by
Thames & Hudson Inc., 500 Fifth Avenue, New York, New York 10110

Reprinted 2023

British Library Cataloguing-in-Publication Data
A catalogue record for this book is available from the British Library

Library of Congress Control Number 2019932288

ISBN 978-0-500-48045-8

Printed and bound in China by C&C Offset Printing Co. Ltd

MIX
Paper | Supporting
responsible forestry
FSC® C008047

V&A Publishing
Supporting the world's leading
museum of art and design,
the Victoria and Albert
Museum, London